Reader's Digest

HOW TO DO JUST ABOUT ANYTHING WITH YOUR
Digital
PHOTOS

Reader's Digest

HOW TO DO JUST ABOUT ANYTHING WITH YOUR

Digital PHOTOS

PUBLISHED BY THE READER'S DIGEST ASSOCIATION LTD
LONDON • NEW YORK • SYDNEY • MONTREAL

Contents

Basics

Photo Projects

About this book
Open up a world of digital photo creativity

Using this book will help you to make the most of your digital camera and tell you how to do just about anything with your digital photos. It will also bring out the creative talents of your camera, in tandem with your PC, using practical and fun projects of real benefit to you and your family.

The opening BASICS section shows you the different kinds of digital camera and the key factors that affect their performance. It then covers the important techniques you need to know for taking the best digital photos. Step-by-step workshops give you hands-on practice so you can hone your photo skills. You'll also learn what to do with your photos – downloading them onto your PC, organising and storing them, manipulating them using image-editing software, and finally printing them for you to enjoy and share with others.

The PHOTO PROJECTS section gives free rein to your creativity while you enhance and transform your digital photos into useful and inspiring end products. At the same time, boxes full of hints and tips are provided that will help you to perfect your photo-editing and other digital skills.

At the back of the book, a comprehensive GLOSSARY provides a quick reference to terms and technology referred to throughout the book.

What you'll need

As well as a digital camera, you'll need a PC running Windows Vista or Windows XP, and a monitor. A printer and a scanner are required for some projects but not all.

At the start of each project are listed the necessary tools – software plus any extra hardware, such as a printer or scanner. Image-editing projects are based on Adobe Photoshop Elements – see 'Image editor' opposite. Any projects involving page layout use Microsoft Word. These programs were chosen because they're the leading products in their fields. If you have alternative programs on your PC – for example, Paint Shop Pro instead of Photoshop Elements – the exact steps may vary, but the broad principles remain the same.

How each project is organised

Following a short description, each project is organised as a series of numbered steps, running left to right across the pages. Above each step is a snapshot of what appears on-screen, with any important details picked out and magnified. Boxes above the steps describe important side issues, ideas or processes associated with the projects.

Within each step, on-screen buttons, menus, or links that you need to click on are in **bold type**. Text to be typed in, including web-page addresses, is in red type. Keyboard shortcuts are also in bold type – for example, **Ctrl+S**, where you should hold down the Ctrl (control) key on your keyboard while you press the S key (then release both keys).

Troubleshoot picture sizing

5 When a picture goes over the bottom margin it's trimmed automatically. If it goes over the right margin, click the **Crop** icon in the **Size** group of the **Picture Tools** contextual toolbar, and drag a side handle to trim it. If the handle is off the edge of the page, or if you make a mistake when sizing, right-click the picture and select **Size** from the pop-up menu. In the **Size** dialogue box click **Reset**.

Software essentials

The programs you'll need to get the most out of the book

Words, and more

Word-processing software can do far more than just produce text. Microsoft Word, the program used in this book, and part of the Microsoft Office

suite of programs, has tools for drawing and for editing photos. Word will even produce web pages. It integrates closely with other Office programs, such as Excel (spreadsheets) and Powerpoint (presentation graphics). You can find out more about Microsoft's Office programs, and download templates and clip art, at office.microsoft.com.

Image editor

You can enhance and transform photos taken with a digital camera, or create images from scratch, using image-editing software. To carry out the photo projects in this book you'll need Adobe Photoshop elements, www.adobe.com/products/photoshopelwin, a budget version of Adobe Photoshop (used by design professionals). Elements has most of Photoshop's powerful features, as well as its look and feel. Before buying an image editor, check whether you already have one – it might have been included as part of your camera or scanner package. (See also 'Introduction to image-editing software', page 20.)

Anti-virus software

Every PC connected to the internet or a network must be protected against damage from viruses.

Anti-virus software such as McAfee SecurityCenter, www.mcafee.com/uk, is updated frequently to keep track of constantly evolving threats.

An alternative, Norton Internet Security, www.symantec.com, is built around Norton AntiVirus, but adds a 'firewall' – a program that monitors all data going into and out of your PC to prevent unauthorised access – as well as a 'spam' filter to reduce the junk emails you receive.

Free software

On the web you will find free alternatives in just about every software category. But make sure you download from a website that can be trusted, such as www.download.com.

Saving and loading documents

With image editors such as Photoshop Elements the standard file format for multi-layer images (see 'How layers stack up', page 26) is a Photoshop-format file (.PSD). For images to be used on the web, JPEG (.JPG) files are the most common (see pages 23 and 38).

To save a document in most programs, choose **Save** from the **Office** button. In the dialogue box, browse to where you want to save the document on your hard disk, type a name for it and, in the drop-down box below, choose one of the file formats shown. Then click **Save**.

To load a document, choose **Open** from the **Office** button, locate the document you want, click it, then click **Open**.

Working with the mouse

Selecting menus, ticking options, drawing and painting, or moving objects are all done with the mouse. The left button is used for most actions, whereas a single click to the right button displays a small pop-up menu of commands relating to what you're currently doing. When you want to paint, cut out, move or resize something – part of a picture, for example – click the left mouse button and drag, then release the button when you're done. A double-click (two clicks in quick succession) usually has the same effect as clicking once and then clicking an **OK** button – for example, when selecting a document to load from within a list of files.

Basics

Simple but important features

Most digital camers offer similar basic functions, such as an LCD screen and memory cards (see page 18). Look out also for these other useful features.

Autofocus

Look for a camera with infra-red autofocus. This focuses the lens automatically, usually when the shutter button is half-pressed (see page 16). Digital SLRs (see right) give you a choice of manual or automatic focusing – professionals often prefer manual focusing as it's quicker and more controllable. Some enthusiast cameras (see right) let you disable the autofocus and use the zoom controls as a semi-manual alternative.

Timer

A 10-second delay timer lets you include yourself in pictures – place the camera on a fixed surface, press the shutter, then walk into the line of shot and wait for the photo to be taken automatically. You can also use the timer to good effect with ordinary shots. If you fix the camera to a tripod and use the timer feature, this eliminates camera shake caused when pressing the shutter button.

Macro

A 'macro' lens mode allows you to focus on detailed subjects close to the camera. Without a macro mode, your photos will be blurred unless you stand at least a couple of feet from the subject. (See also pages 16 and 19.)

Choosing the right camera
A quick guide to the types and their features

Digital cameras come in all shapes and sizes. Ususally, you get more megapixels (see pages 22 to 23) and a better lens the more you spend, though most cameras will give adequate images. Cameras can be grouped into four categories, ascending in capability and price. To find a bargain, look for models that have been out for a few months as prices fall rapidly after launch.

Ultra-compact

The simplest of digital cameras, an ultra-compact is designed to slip into a pocket and be easy to use – just pull it out, switch it on, and point and shoot. Ultra-compacts make good party and holiday cameras because of their size and simplicity. The cheapest models may not have a flash, which is unhelpful for indoor shots, or an LCD monitor. On the other hand, some ultra-compacts are powerful, with autofocus (see left) and high-megapixel image capture.

Compact

This is the most popular camera, with a good balance between price and features. Compact cameras are made to fit into coat pockets and handbags, and they invariably have the essentials of everyday digital photography, such as a built-in flash, an autofocus zoom lens (see left), LCD monitor, and support for memory cards (see page 18). Some compact cameras even have special functions such as multimedia recording and playback, and filter effects (see page 12).

Enthusiast

Digital cameras aimed at the photography enthusiast tend to look like traditional cameras, though the styling is largely cosmetic to distinguish them from compact types. Enthusiast cameras are larger than compacts, partly because they have larger, higher-quality lenses and often use bigger battery packs. The picture controls are more advanced than those for compacts, too, offering features such as histograms ('maps' of how the tones in an image are distributed) and the manual adjustment of shutter speed.

Digital SLR

Professional and serious amateur photographers are likely to buy the digital equivalent of an SLR (single-lens reflex) camera. The image sensor that captures the photos inside the camera is usually much larger than those for non-SLRs, producing clearer pictures that contain more colour and light information per pixel. Digital SLRs usually allow you to change lenses and provide a connection, or 'hot-shoe', for add-on hardware such as flashguns.

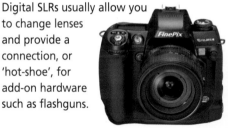

A tour around a digital camera

A Microphone Cameras that let you record audio and video as well as still images are fitted with a tiny built-in microphone. This can be found on the front or the top of the camera, or sometimes both.

B Warning/red-eye lamp Many cameras have a small lamp next to the flash unit, activated mainly when you select 'red-eye reduction' mode. The lamp flashes a few times to help close the subject's irises before the shot is taken. It may also act as a blinking 'get ready' signal if you use the timer feature.

C Flash Most cameras include a built-in flash lamp. In autoflash mode, the camera enables or disables the flash according to the current light conditions, although you can normally

also force or disable the flash manually. Some enthusiast and digital SLR cameras have pop-up flash units.

D Optical viewfinder A traditional optical viewfinder is less accurate than an LCD monitor for lining up a shot, but it saves battery power by leaving the LCD monitor switched off. The optical viewfinder on some enthusiast and digital SLR cameras is actually a mini LCD monitor, similar to what you'd find on a digital camcorder.

E Memory card compartment The camera's removable memory card (see page 18) is protected behind a door to keep the dust out. In some cases, it may be found alongside the battery compartment.

F Lens Compact cameras usually have retractable lenses that sink inside the body of the camera when not in use. Enthusiast and digital SLR cameras typically have protruding or even interchangeable lenses.

G In-out sockets Virtually all cameras have a set of in-out sockets, often protected by a rubberised cap. One is a data socket for attaching the camera to your PC by a cable so that you can download the pictures. Your camera may also be fitted with an audio-visual socket for connecting to a TV so that you can present a sitting-room slideshow. Additionally, there may be a power input connector for use with a mains adapter.

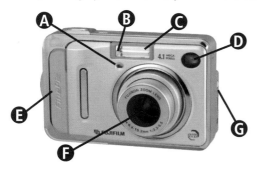

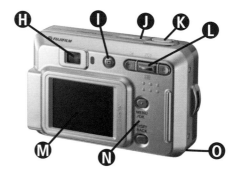

H Optical viewfinder (back) At the back of many cameras there is a light sensor next to the optical viewfinder. This detects when your face is close to the unit and automatically switches off the main LCD monitor to save battery power.

I Playback button This button puts the camera into 'review' mode, letting you browse through the pictures you've taken. Press it again to return to 'capture' mode, ready to take the next picture.

J Flash button A button that enables or disables the flash at the front of the camera, overriding the default autoflash mode. Not all cameras have this button – you may need to

select the flash mode using the camera's on-screen menus.

K Shutter button The largest button on the camera – press it to take a picture. The autofocus feature, found on most cameras, is enabled when when you press the shutter button halfway down.

L Zoom controls To zoom in and out, press the left and right-hand buttons. Some cameras have a single zoom button that slides or rocks from side to side. The zoom controls are usually located on the rear of the camera at the top right.

M LCD monitor This colour screen is used for lining up shots before you take them and

reviewing pictures you have already taken. It is often also used for navigating the camera controls via on-screen menus.

N Menu buttons A set of additional buttons may be provided so you can use special features in the camera, such as macro mode (see page 10), or navigate the on-screen menus on the LCD monitor.

O Battery compartment Most digital cameras are powered by removable batteries inserted behind a lockable door. On some cameras you can fit rechargeable batteries, which can then be recharged while inside the camera by plugging it into the mains supply.

Built-in camera effects

This book will show you how to enhance and edit your pictures using software on your PC. Many digital cameras, especially the compact and enthusiast types (see page 10), already come with some built-in special effects that can be applied to the pictures before they are even downloaded onto a computer.

The most common effect converts colour photos to black and white, which allows you to switch between colour and 'monochrome' instantly. Another popular effect is 'sepia', which applies an old-fashioned yellow-brown tint across the picture to mimic the effect of age. While these simple effects are usually applied to single pictures after they have been taken, some cameras will let you switch into black and white or sepia mode while actually shooting a photo.

Certain compact cameras are loaded with more exotic effects – 'vignettes', for example, which fade the edges of pictures (see page 93). Some effects have children in mind, such as colourful picture frames, text captions, and decorative layers of stars and balloons.

Digital camera basics
The simple things you need to know about your camera

When you choose your first digital camera, or up-grade to a new one, you could be faced with a lot of technical specifications. Although this is all relevant to the camera's performance, there are only a handful of important facts and figures you need to know. Here's a quick guide to some key areas of how a digital camera works.

Resolution and megapixels

In general terms, the more 'pixels' in an image, the higher its visual resolution (see pages 22 and 23). To help you distinguish between the resolutions offered by different cameras, they're loosely rated according to the overall number of pixels they capture in an image. Every million pixels is referred to as a 'megapixel'.

Zoom lenses

Digital camera lenses are rated in the same way as those of traditional 35mm film cameras. For example, a good zoom lens might be said to have a range between 38mm and 114mm. It's easier to look for a simple specification based on multiples – for example, 2x means double zoom, 3x means triple zoom, and so on.

Compression and quality

All but the top professional cameras compress the picture data – the pixels – to make smaller files to fit inside the camera memory. The most common type of picture file is the JPEG format (see 'Advanced picture formats' opposite and 'Size matters' on page 23). This uses a sliding scale of compression – the higher the compression, the smaller the file size but also the poorer the image quality.

Memory card

Your pictures will be stored on a memory card within the camera. There are many different types of memory card, such as Secure Digital, Microdrive, Compact Flash and Memory Stick, but your camera will almost certainly only support one of them. See 'Digital film' on page 18 for more information on memory cards.

Batteries

Different cameras use different types of battery. Single-use alkaline or lithium batteries last a long time but are expensive. Rechargeable batteries drain more quickly but will save you money. When buying rechargeable batteries, find out whether you need to buy a separate recharger, and make sure you buy batteries with the minimum amp and voltage rating (such as '1500mAh, 1.2v') required by your camera. This information should be included in the user manual.

Aperture and exposure

Only the top of the range digital cameras follow the traditional arrangement of a physical iris and shutter controlling the aperture – the opening that lets light into the camera (see 'Understanding camera controls', page 16). The effect of 'f stops' (manual adjustments of the size of aperture) and exposure (the amount of light that enters the camera, controlled by aperture and shutter speed) are usually mimicked electronically in compact cameras.

The new talents of the camera

How you can do much more than just take pictures

Modern digital cameras often offer more than simply the ability to take still pictures. Camera manufacturers like to build additional features into their products to attract your interest away from the competition. So if you want to have some extra fun with your camera, look for these features before you buy.

Sound recorder
Being able to record audio on a camera means you can add verbal reminders about each picture, rather than having to scribble down notes. This feature also means that you can record conversations or use the camera like a dictaphone.

Video recorder
Many cameras let you capture quick video clips (usually with sound) as well as still images. You can then view these mini films on the camera LCD monitor or download them on to your computer. See also 'Taking video with your camera', page 19.

Web cam
Some cameras are supplied with software that turns them into web cams so you can communicate face-to-face with people over the internet. Even cameras without built-in sound or video recording can sometimes do this. Alternatively, if you have web cam software (often available as a free download) on your computer, you may be able to use your camera for the video element simply by connecting it to your PC by its download cable.

Music playback
Some cameras incorporate stereo MP3 players that can play back downloaded music. This is less common on digital cameras than it is on mobile phones.

Wireless sharing
Some digital cameras now support Bluetooth wireless connections. This allows you to download pictures to your PC without the need for any cables, to exchange pictures with other cameras, or to upload pictures to a mobile phone for instant emailing to friends and family.

Advanced picture formats
The picture file format used by most digital cameras is known as JPEG (or JPG). This format has the advantage of compressing pictures into the smallest possible files, and so saving on memory. The main disadvantage is that it doesn't support the high-quality image standards that professional photographers demand.

For this reason, all professional digital cameras, and an increasing number of enthusiast cameras, capture shots to an alternative picture file format known as 'Camera Raw'. This format saves the light information seen by the camera in its raw state – with no adjustment, compression or conversion. This gives you more control when editing the picture in PC software.

Camera Raw has disadvantages of its own. The files are much larger than JPEG pictures – easily four times bigger or more – and they soon fill up memory cards. A further problem is that Camera Raw isn't a fully standardised file format like JPEG, so there are different versions of the Camera Raw format, depending on the camera model and manufacturer.

Adobe Photoshop Elements, the picture-editing software recommended for use with this book (see page 7), lets you open and adjust a wide range of Camera Raw versions.

Optical and digital zoom
When you buy a camera with a zoom lens, you may notice that the product specifications give two zoom figures, such as '8x/12x'. The lower figure is the true optical capability of the zoom lens. The higher figure is an artificial zoom effect achieved by expanding the picture in software and inserting new pixels between the existing pixels – a process known as 'interpolation'. Digital zoom can be helpful for framing distant subjects beyond the range of the optical zoom, but can produce blurry results. See also 'Make the most of optical zooms', page 18.

Getting at your pictures
Downloading your digital photos to a PC and then printing them

Taking pictures with a digital camera is easy and fun, but you need to unlock them from inside your camera. Some cameras can be linked to photo printers that let you output pictures directly from the camera onto glossy photo paper. But ideally you should regularly transfer the pictures to your computer, a process known as 'downloading'.

Downloading the pictures has two benefits. It frees up space on the camera's memory card (see 'Digital film', page 18), letting you take more pictures without having to buy additional cards. It also lets you edit and experiment with the pictures on your computer using an image-editing program such as Adobe Photoshop Elements (see page 7).

To follow the photo-based projects in this book, you need to know how to download your pictures from your camera. Here are the main ways you can do it.

From cable to computer

All cameras have a cable that attaches to a USB (Universal Serial Bus) port on a PC. You may have one or two USB ports at the front, which makes the job easier. Once the camera is attached, turn it on and follow the steps below to download the pictures using Photoshop Elements (see page 7). Some cameras have a 'PC connection' mode that you need to select, but it's usually automatic.

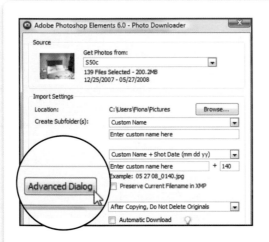

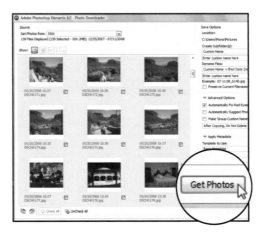

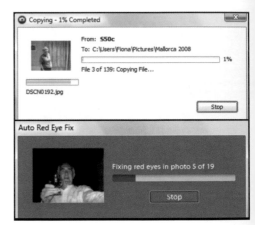

See what's on your camera

1 Connect the camera to your computer – Photoshop Elements' Photo Downloader should launch automatically. If it doesn't, select the program from the right-hand side of the taskbar. Use the options in the Import Setting panel of the dialogue box to select where your pictures will import to. Click the **Advanced Dialog** button at the bottom left to view thumbnail versions of the pictures you've taken.

Select the photos you want

2 Here you can remove the tick next to any shots that you don't want, for example those that look identical, such as views taken on a family holiday. If your digital camera supports video and audio recording, the movie and sound files will be there too, although only as icons. Untick the items you don't want to download, then click the **Get Photos** button, located at the bottom right of the dialogue box.

Download the pictures

3 As each picture you've selected is downloaded to your computer, a progress bar is shown on-screen, along with the photo's thumbnail. Bigger files take longer to download but they should only take a few seconds each. If you've selected any automatic image-adjustment filters, such as red-eye correction, Photoshop Elements will apply the filter to every downloaded picture.

Memory card

If your camera has a removable memory card (see 'Digital film', page 18), you can download pictures using a 'card reader', which can be bought from any camera shop. It's a little block containing various memory card slots that attaches to a PC via a standard USB cable (see left), or it may be supplied moulded on to its own cable. Then you just slip the memory card out of your camera and slot it into the reader. It will be recognised instantly by your PC and treated just like a camera-full of pictures.

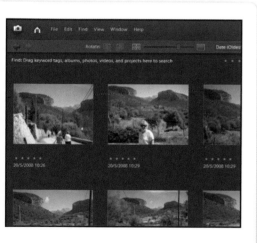

Organise your photos

4 When the download process is complete, your picture thumbnails are automatically displayed in the organizer view of Photoshop Elements. Here you can organise the pictures into new groups, give them names and add 'keywords' to the pictures to help you search for them later. Elements also provides a **New Photos** view that shows only the pictures you last downloaded.

Photo printers

Many photo printers have built-in memory card readers. They may also provide a special USB-style socket known as a 'PictBridge' port. Cameras that support PictBridge (most do these days) can be connected straight to the printer at this port using the USB download cable they came supplied with – see opposite. Either way, these features let you print straight from the camera or download the pictures easily to your PC through the printer.

Bluetooth

The same wireless connection technology, Bluetooth, popularised by mobile phones, is available on some digital cameras. They can use Bluetooth to download pictures without the need for a cable or the removal of the memory card, so long as your computer supports Bluetooth. This can be added to any PC with a tiny adapter that plugs into a spare USB port.

● **Send pictures to your camera**

As well as downloading pictures from camera to PC, many cameras let you upload pictures in the opposite direction – from your PC back to the camera again. This means you can put any pictures onto the camera, no matter when they were taken, and use the camera as a portable photo browser. For example, you could collect your favourite pictures taken of a newborn baby, upload them to the camera, then show them to friends at work without having to churn through all the indifferent shots you also took.

Windows download programs

You don't have to use image-editing software such as Photoshop Elements to download pictures from a digital camera. You can also organise your photos using an alternative 'media manager' program on Windows Vista called Windows Photo Gallery. This is useful if you can't get to your own PC – while on holiday, for example – but still want to download the pictures to a computer and maybe write them to a CD to free up space on the camera's memory card.

To activate the Windows Photo Gallery software click the **Start** button and select **All Programs**, then **Windows Photo Gallery**. Connect the camera as described in step 1, page 14, and switch it on. Click **File**, then **Import from Camera or Scanner**, select your camera from the options shown, then click **Import**. Untick any pictures you don't want and then click **Next** to specify where the downloaded pictures should be saved. When completed, you'll have downloaded the pictures you wanted and deleted the originals from the camera's memory, freeing it up to take more pictures.

Become a digital sharp shooter
Your guide to taking photos like a professional

Understanding camera controls

The size of the hole through which light comes into the camera is the 'aperture', the length of time the hole is open is the 'shutter speed', and these add up to the 'exposure'. Your camera automatically works out the right exposure for each picture so it doesn't come out too bright (overexposed) or dark (underexposed).

The larger the aperture, the smaller the 'depth of field'. That means only objects at a certain distance will be in focus, while those nearer to the camera and those further away from the camera appear blurred. Most cameras have an 'aperture priority programme', labelled Av. You can fix a large or small aperture, and shutter speed adjusts accordingly. Alternatively, 'shutter priority' (Tv) lets you set a fast speed, so a moving object will appear sharp and still, or slow, allowing 'motion blur' to give an impression of movement.

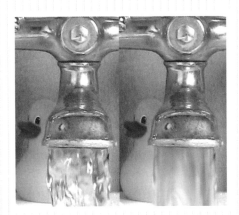

By selecting your camera's shutter priority programme, you can shoot fast to freeze motion such as falling water, or slow to let it flow.

Why scour the internet looking for photos to use for projects, when you can take your own? And today's compact digital cameras are quick and simple to use – there's no need to do anything more than point and shoot. But that doesn't mean you should take pictures without any thought. Paying attention to a few basic principles will improve the quality of your pictures, giving you a good basis for PC image-editing projects. The better the quality of the original photo, the better the result

Keep your subject sharp

Your camera focuses automatically on whatever is in the centre of the frame. So if you compose a picture with the subject to one side, the camera may focus on the background and the subject won't be sharp. To avoid this, point the camera directly at the subject and press the shutter button halfway down. A beep or an indicator light will confirm you've fixed the focus. Keeping the button held halfway, move the camera to compose the shot then fully press the button.

of the editing process, whether you're giving your picture a final polish or trying something more creative. On these pages you'll find out some of the reasons why photos come out badly and how to avoid them. You'll also learn how your digital camera's manual controls can help you achieve great results in tricky or unusual circumstances.

One good piece of advice for users of digital cameras is simply to take more pictures. Shoot the same subject at least three times, varying your camera settings and position so there's an excellent chance of getting at least one shot that you're happy with.

Get closer with macro

To take close-up shots, simply select your camera's macro mode, usually indicated by small icon of a flower. This will let you focus as close as 2 to 20cm depending on your camera. Normally a flash is overpowering, so it's been switched it off here.

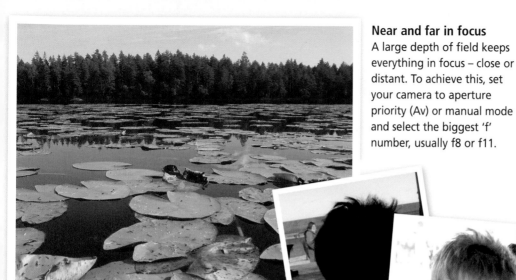

Near and far in focus

A large depth of field keeps everything in focus – close or distant. To achieve this, set your camera to aperture priority (Av) or manual mode and select the biggest 'f' number, usually f8 or f11.

Expose your subject correctly

It's tricky to get a good photo of someone if there's a strong source of light in the background, such as a window. The rear light will cast the person's face into shadow, and the camera's auto exposure will be confused by the high contrast between dark and light areas. Most cameras have a 'backlight compensation' mode that you can select when taking such shots. You can also try the half-press trick, as with focusing, to lock on the area you want correctly exposed.

Avoid photo pitfalls

Some of the most common mistakes in photography are the most obvious. Ensure you're holding the camera steady, and preferably braced using a tripod or at least a solid support of some kind – tables, walls and benches are all useful – so that you don't blur the picture. Check the viewfinder or, even better, the LCD screen and make sure that everything you want in your picture is within the frame, without being too small. If there is little light, find a way to get more, either by opening curtains or shutters, turning on electric lights or using flash.

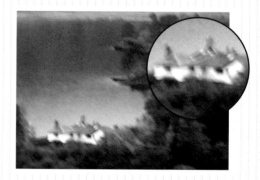

Remember, flash only works well at a distance of 2 to 5 metres from the camera; any less will 'white out' your subject, while the flash won't illuminate anything further away. Finally, remember the worst photo is the one you didn't take at all: keep your camera handy.

Shake and blur

Wobbling the camera will spoil a photo because everything becomes blurred. But here blur is used to heighten the dramatic effect of the horses speeding past. This is 'motion blur'. A faster shutter speed (see 'Understanding camera controls', opposite) will reduce the effect.

Digital film

With a traditional camera, your pictures are stored on a roll of film. A digital camera stores images on electronic memory cards. These come in a range of shapes, sizes and storage capacities, depending on the make and model of camera. The type most commonly used in compact cameras is Secure Digital (SD), while professional cameras use the slightly larger Compact Flash cards. Sony products use a proprietary type of card called Memory Stick. And mobile phones that have cameras built in often use postage-stamp sized cards known as Mini-SD. It makes little difference what format your camera uses, but you can only insert the correct type of card.

All these cards are based on a technology called 'flash memory' that keeps what's stored even when the camera is turned off. So, having filled up the card, you can take it out and leave it to one side while you shoot on another, then transfer the pictures to your PC when you're ready.

You could keep all your photos stored on cards indefinitely, but it's an expensive way to preserve them. It's best to copy them to your PC then back them up onto recordable CDs or DVDs. You can then reuse your memory card or cards to take more pictures.

Make the most of optical zooms

Zoom is an important feature to look for when buying a camera. It's useful both practically, to get more detailed shots of distant subjects, and creatively. Using zoom changes the relationship between foreground and background. Nearer objects don't look so huge, and there's more difference in focus at different distances, so you can make your subject stand out sharply against a blurred background.

All of this is only true of 'optical zoom' (see the picture top right), which works by moving lenses within the camera. 'Digital zoom' doesn't affect the picture captured by the camera, but magnifies the centre of it to fill the whole frame. The resulting image (as seen in the picture middle right) is far less clear and the pixels are clearly visible.

Up close and personal

Portrait shots don't have to include the whole head and shoulders. Experiment with unusual angles and get in close, but don't waste too much time composing the shot – if you're slow off the mark you will miss the moment. Try to maintain eye contact with your subject.

When darkness falls

Night shots require exposures between 1 and 4 seconds, but also try experimenting in shutter priority or manual modes (see 'Understanding camera controls', page 16). To keep your camera steady, use a tripod or balance it on top of a wall; the self timer will eliminate the chance of wobbles. Unless you have a friend in the foreground, switch off the flash.

Sparkling action shots

Capturing sparklers requires a combination of a flash for the person and a long exposure for the sparkler. Set your camera's shutter speed to around 2 seconds (see 'Understanding camera controls', page 16) and force the flash to fire – some cameras call this a 'slow synchro' mode.

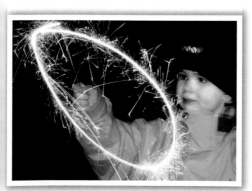

Exaggerate depth of field using macro

Macro mode isn't only for shooting small objects (see page 16). You can also get a dramatic depth of field effect by positioning the camera very close to an object and using macro to focus on it. More distant objects will be progressively blurred.

Relief for red-eye

When you photograph a person using the flash, light reflected from the back of the eyes glows red, known as 'red-eye'. In low light – when you'd be using flash – the pupils of the eyes are wide, increasing the effect. Red-eye reduction, an option on most cameras, fires off several mini flashes to make the pupils contract. Thankfully, red-eye is quickly remedied in most image-editing programs.

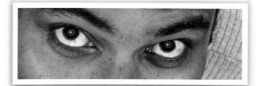

Taking video with your camera

Many digital cameras have a video recording feature for capturing real-time live action, usually with audio, to movie files. These files can be played back on the camera's monitor display or downloaded to your computer for playback using Windows Media Player.

Don't expect video quality as high as you would get with a digital camcorder, although you can obtain good results if you follow a few guidelines. First, avoid using your camera's zoom function while shooting video. Not only does zoomed-in video accentuate the effect of camera shake, but the noise of the lens motor will be picked up by your camera's built-in microphone.

Second, pick your moment carefully to start shooting. Most cameras only capture videos of a specific time length – anything from ten seconds to one minute – so if you start too early, the climax of the action might be cut off. Then, when you finish shooting, the camera usually spends another minute or so saving the movie, preventing you from shooting again until the process has finished. Finally, keep some spare memory cards handy (see opposite), as movie files take up lots of memory.

Image makers

Learn how to transform your photos with the help of Photoshop Elements

Using an image-editing program, you can make almost any imaginable alteration to a photo or scanned-in picture. First of all, you need to have the picture stored as a digital file. It could come from your digital camera, or the picture may have been taken on traditional film – you can have photos put on CD when you have your film processed, or use a scanner to copy prints onto your PC (see page 34).

Image-editing programs have 'photo', 'paint' or 'image' in the name. Examples include Microsoft Digital Image Suite, Corel Paint Shop Pro, and Adobe Photoshop. Photoshop is the most powerful image editor and has a popular lower-cost version called Photoshop Elements, which is the program used in this book (see pages 14 to 15). Image editors are distinct from other kinds of graphics programs such as drawing software,

which creates pictures from geometric shapes and isn't suitable for editing photos.

Having opened an image file in your program, you can alter it in a variety of ways. At the simplest, you can turn it around, straighten it up or 'crop' it, which means that only a chosen rectangle is kept while the rest of the picture is discarded. Using colour correction and adjustment commands, you can change the overall

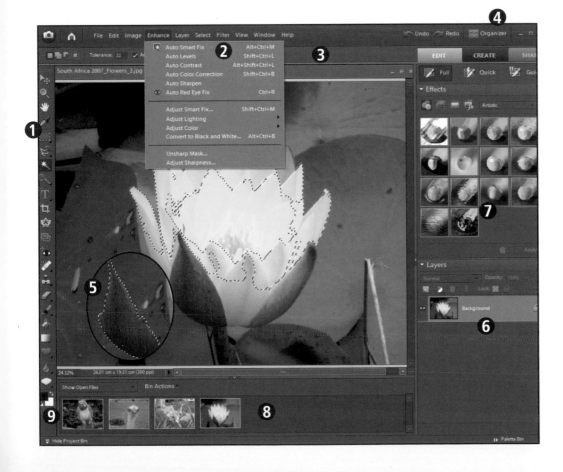

1 Most image-editing programs have a similar set of tools arranged in a toolbox such as this. Some tools are unique to each program.

2 Tools are used with the mouse and affect the picture only where you click. The menus offer adjustments that affect the whole image.

3 Each tool has settings to adjust how it works. You set these in the Options toolbar.

4 An Organizer lets you look through small 'thumbnail' views of all the pictures on your PC, a CD or DVD to find the one you want.

5 Use the various selection tools to draw around an area of a picture so that you can alter that area without affecting the rest of the image.

6 You can place several pictures on top of each other in transparent layers. An ordinary picture file has one layer, called Background.

7 Ready-made styles can be applied to layers. To turn a plain circle into a translucent 3D button click one of these styles.

8 Photoshop Elements' Photo Bin shows all the pictures you've opened. You can quickly switch between them or copy from one to another.

9 Click these swatches to change the colours that will be applied when you use tools such as brushes.

appearance of a picture, for example if it's too light, too dark or the wrong colour. Specialised tools will correct common problems such as 'red-eye' (see page 19), where flash photography causes people's eyes to appear red.

There are special effects for more creative projects, too. Many tools work directly on areas of a picture using the mouse as if it were a brush. You can paint colour onto an image, even make a painting from a blank canvas and apply effects freehand. For example, you can lighten, sharpen or smooth the area you paint over. You can also use a 'clone' tool to paint one part of a picture over another – for example, painting grass and sky over a telegraph pole to remove it from a landscape.

Functions can be applied to the whole of an image or just to selected areas – options help you mark out exactly the parts you want (see page 32). You can also split the image into separate layers, arranged like transparent sheets stacked one on another (see page 26).

Image-editing techniques

There are various effects you can apply to your images, ranging from traditional photographic tricks, such as turning an image into a negative, to imitations of artistic styles such as oil painting or mosaic tiles. It pays to experiment, but always keep a backup copy of your original photo.

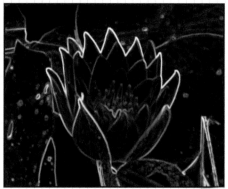

In the first example, above, a picture of a flower has been turned into a neon sign using an effect called **Glowing Edges**. Not only the colours but even the shape of a picture can be changed radically.

Photoshop Elements offers many ways to distort all or part of an image. In the second example, right, a distortion effect called **Polar Coordinates** is used to make the flower appear as if it's inside a glass ball.

If you want to alter only part of an image, you can make a 'selection'. There are several ways to do this –

see pages 32 to 33. Once you've made a selection, it's shown by a flashing dotted outline, and any adjustment or effect will work only inside this. In the example below, the flower has been selected (as seen in the screen on page 20) and made brighter and sharper, while the

background has been made darker and more blurred. This allows the flower to stand out more.

Or you can even use a photo as the basis for abstract art, or to create a background texture. In the final example, below, a 'craquelure' effect has been applied to the photo, giving the impression of a cracked painted surface.

Pixel perfect
Get to grips with the principles of colour and image resolution

A digital image such as a photo is made up of a grid of 'pixels' (the word is derived from 'picture cells'). The number of pixels is its 'resolution'. Think of it as a huge mosaic, with millions of square tiles of different colours forming the picture. When looked at from a distance, the tiles that make up a mosaic are small enough that you don't notice them; you simply see the picture.

In a similar way, as long as enough pixels are packed into a digital picture, that image appears sharp and clear.

For this you need about 300 pixels across and 300 pixels down every square inch of a printed page. A PC monitor has about 100 pixels per inch. So, for best results, you can only print out a picture about a third as large as it appears on screen when displayed at

100% or 'actual size'. In practice, though, 150 pixels per inch will often produce acceptable results.

Colour in the digital world
Your monitor generates colours on screen by varying the amounts of red, green and blue (the three colour 'channels') in each pixel. The number of different colours that can be

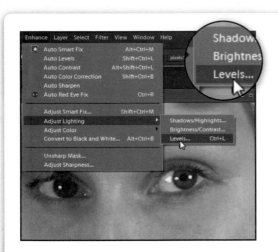

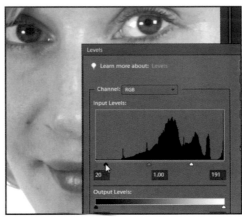

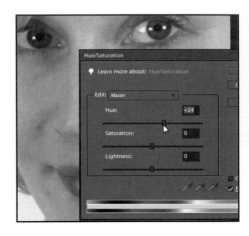

Correct a problem photo

1 This photo, opened in Photoshop Elements, has obvious colour problems. There's little contrast and the colours look odd. When judging colour, it helps to get an overall impression of any 'colour cast'. Look at the picture alongside another one that you know you're happy with. You can also judge from familiar picture elements, such as the skin tone, as here, or the whites of the eyes.

Adjust tone levels

2 To improve the tone and colour of your photo, click the **Enhance** menu and select **Auto Levels** or **Auto Color Correction**. One of these may provide an instant fix. For more control use **Levels** (press **Ctrl+L**). A graph displays the distribution of colour values in the image. To increase contrast, drag the black slider on the left and the white slider on the right inwards to the edges of the graph.

Tweak the colour

3 Now there's more contrast, but the colours are still wrong. Choose **Adjust Hue/Saturation** from **Adjust Color** on the **Enhance** menu (or press **Ctrl+U**). The problem here is hue: that is, what colour things are, rather than how bright (saturation). Move the **Hue** slider. In this case, a move to the right makes the skin look more natural. The lips and eyes look better, too.

displayed is determined by an image's (or monitor's) colour depth, expressed as a binary number (zeroes and ones). Most equipment uses a colour depth of 8 'bits' – the binary digits that store digital information – for each of these channels, giving the equivalent of the decimal numbers 0-255. For example, bright red is R=255, G=0, B=0 (full red, no green, no blue). Three channels of 8 bits gives a total of 24-bit colour, called 'true colour' because it's enough to represent all the colours that the human eye can distinguish.

Your digital camera or scanner records the colour value of each pixel. Your PC manipulates those values when you edit images, and your monitor and printer then display the colours for you to see. 'Colour management' is needed to make sure they all interpret colour values the same way. This is done automatically by Windows and software such as Adobe Photoshop Elements. Always turn on colour management where it's offered, and tick the option to save a 'colour profile' with each picture so that other hardware and software will know how to handle it.

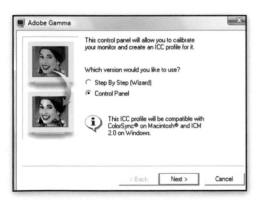

*Run the Adobe Gamma program, found in **Control Panel** on the **Start** menu, to perform a simple calibration that will help make sure your monitor is displaying images correctly.*

Size matters

The resolution of an image is usually given in 'dots per inch' (dpi). The term '300dpi' means 300 dots across and down each inch. 'Dots' here means pixels. Don't confuse these with the dpi ratings of printers, which refer to ink dots, of which dozens are needed to print each pixel. Digital cameras are rated in megapixels, referring to the total number of pixels (in millions). For a photo to print at 8x6in and a resolution of 300dpi, you need 8x300x6x300 = 4,320,000 pixels, just over 4 megapixels.

An image stored at high resolution. The same image stored at lower resolution.

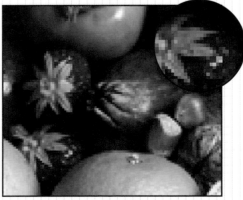

*Elements' **Resize** option illustrates how the number of pixels in your image divided by the resolution equals the printed size.*

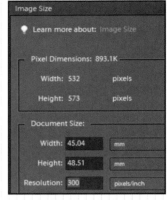

Storing a 'true colour' digital picture requires 24 bits multiplied by the number of pixels, which soon adds up to a lot of megabytes to fit on a memory card or on your PC's hard disk. One way to save space is to reduce the number of pixels, for example by setting your digital camera to a lower resolution. Another is to use data compression, such as that used in JPEG (pronounced 'jay-peg') image files. When you store a picture in JPEG format, colour information that the eye won't really notice is discarded. In your digital camera or image-editing software, you set the level of compression to balance quality against size. Remember that once data is lost, you can't get it back.

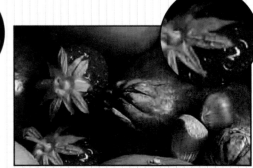

Image stored with heavy JPEG compression.

Paper, inks, printers – action!

How to get the best printouts from your pictures and layouts

Your photo projects may begin on your PC screen, but often the result will come out of your printer. One of the joys of using Windows is that with a little practice you can get perfect printed results every time, even with an inexpensive printer. In fact, a run-of-the-mill colour inkjet printer – probably cheaper than a meal for two in a restaurant – will churn out professional-looking documents for as long as it's got ink in its cartridges.

Inkjets are by far the most popular kind of printer and most can handle any paper size, from a 6x4in photo to an A4 page. Print quality depends not only on the printer but also on the paper you choose – with glossy photo paper, results can be indistinguishable from a traditional colour photo, while printing won't look as rich or crisp on plain paper.

Why inkjet printers are so cheap is an open secret. Printer manufacturers don't make much of their profits on the actual printer, but on what goes inside it: the refills.

Letting the experts do it

You don't have to print out your artwork yourself. There are lots of companies that offer photo printing services, including high street shops such as Boots and Jessops. You can take your digital camera's memory card into a shop and pick up the prints later. Or you can upload pictures from a computer over the internet and get quality prints on proper photographic paper through the post. You can even order enlargements, or special items such as mugs or T-shirts.

If you check the prices in your local stores or on the internet, you'll see that, relative to the purchase price of the printer, ink refills are expensive. That means you should think before you print; especially with large colour photos.

Printer settings

Windows programs work on the 'what you see is what you get' (WYSIWYG) principle, meaning that your printed work appears as it does on screen. But translating an image into dots of ink is a complicated process, so your printer comes with 'driver' software to control it. When you choose the **Print** command in any program, the box that appears will include a **Properties** or **Options** button to take you to settings provided by the printer driver. For example, you select what kind of paper you're using and adjust colour settings according to the type of document you're printing. Such settings provide the best quality for each print job.

Print quality is limited by the resolution of your original image, too. This doesn't apply to text in a word processor, which will print smoothly at any size. But when you print a digital photo, the largest size at which it will look sharp in print depends on the number of pixels it contains (see page 23). If you create a new document in an image-editing program, remember to set its width and height to the size you want to print it and its resolution to 300 pixels (or dots) per inch.

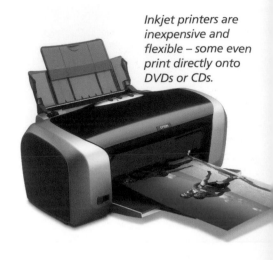

Inkjet printers are inexpensive and flexible – some even print directly onto DVDs or CDs.

Print your own CD box artwork

1 Run Photoshop Elements and select **Edit**. Choose **Open** from the File menu to load a suitable image file for your CD cover. Press **C** for the **Crop Tool**. In the **Options** bar at the top, set **Width** to **12.1cm** (4.75 inches) and **Height** to **12cm** (4.725in). Set the **Resolution** to **300 pixels per inch**, for high-quality printing. Click on your picture; hold the mouse button and drag to make a rectangle.

Printing to PDF

Instead of giving someone a printed document you can email it as a Portable Document Format (PDF) file. Anyone can view and print PDFs using Adobe Reader, a free download from www.adobe.com. To make PDFs, you use a PDF 'printer driver': when you go to **Print**, it lets you save as PDF instead. Free PDF printer drivers include PrimoPDF from www.primopdf.com and Pdf995 from www.pdf995.com.

With a PDF driver you can 'print' documents to a PDF file from any program. Pages appear on screen just as if they were printed.

Ink refills

Save money by refilling the plastic cartridges that hold the ink for your printer instead of discarding them when empty. You can take your used cartridges to a high street refilling service or buy your own kit. Kits can be bought from computer stores, stationers and most big supermarkets. Printer makers don't recommend using non-original replacement cartridges or refills on the grounds that the inks are inferior.

Add a title

2 Adjust the rectangle to enclose the area you want to use, holding the spacebar to reposition it. Double-click, or click the tick symbol at the bottom right of the rectangle, to crop and size the picture. To add words, click **Horizontal Text Tool** in the toolbox. Click the picture and type your CD's title. Click and drag over the text to highlight it, and then use the **Options** bar to choose the font, size and colour of your text.

Edit the text

3 If you want to reposition your title, press **V** for the **Move Tool**. Once the title has been placed in its new position, press **T** to return to the **Text Tool**. Click elsewhere on the picture to add more text in the same way. When your design is finished, choose **Print** from the **File** menu. You're shown a mini preview of the printout. Make sure that **Scale** in the **Scaled Print Size** panel is set to **100%**.

Choose the paper, and print

4 To confirm the size of paper you're using, click **Page Setup**. Click **Print** to show a box where you can confirm which printer you want to use. Click either the **Preferences** or **Properties** button to go to the settings provided by the printer driver. Finally, click **OK** to print your CD insert. You could print a label for the CD, too – sticky labels are available in kits, while some inkjets can print onto printable CDs.

Editing multi-layered images

Take your creativity further by combining images in layers

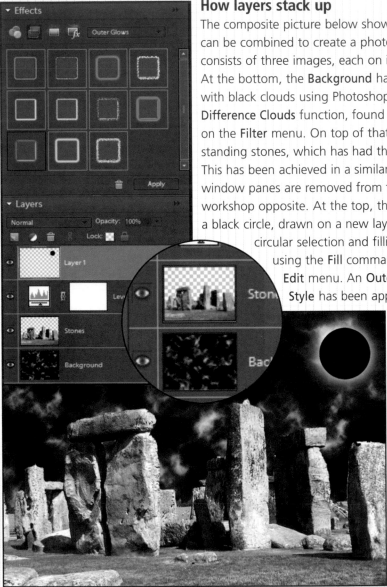

How layers stack up

The composite picture below shows how layers can be combined to create a photomontage. It consists of three images, each on its own layer. At the bottom, the **Background** has been filled with black clouds using Photoshop Elements' **Difference Clouds** function, found under **Render** on the **Filter** menu. On top of that is a photo of standing stones, which has had the sky cut out. This has been achieved in a similar way to how the window panes are removed from the picture in the workshop opposite. At the top, the solar eclipse is a black circle, drawn on a new layer by making a circular selection and filling it with black using the **Fill** command from the **Edit** menu. An **Outer Glow Layer Style** has been applied to add the yellow halo.

On top of the standing stones is an 'adjustment layer'. Instead of an image, it holds settings for adjustments that can be applied to the underlying layer or layers. In this example it increases the contrast on the stones. The advantage is that you can alter or remove the adjustment at any time, leaving the original image or images intact.

Blending layers

Each layer has an **Opacity** control, which sets how transparent it is, from **100%** (solid) to **0%** (invisible). It also has a blending mode. **Normal** blending means the image in the layer covers what's underneath. There are many alternative blending modes. With **Multiply**, colour in the layer is added to underlying colour, darkening the image. In **Screen** mode, only lighter areas of the layer are seen. Experiment and you'll soon get the idea.

An important aspect of image editing is the ability to combine pictures. For example, you can take a photo of yourself and superimpose it on a picture of a famous place, assemble a collage of items collected on holiday, or overlay an image on top of another, to create a double exposure effect.

To achieve such images you use 'layers'. Think of layers as transparent sheets with pictures printed on them. Wherever part of a layer is empty, the picture below shows through. You can make the pictures more or less transparent, too. Any number of layers can be stored in one image file. The **Layers** box lists them in order, from top to bottom, and you can make each temporarily visible or invisible. Where there's no visible content on a layer, you see a checkerboard pattern.

The current combination of visible layers is what you see in the main editing window and it's also what's stored if you save your work as an ordinary image file such as a JPEG (see page 23). When you save in your software's own format, such as Adobe Photoshop Elements' .PSD, all the layers are kept so you can edit them independently again at a later point.

Layer styles

A layer will often contain a 'cutout' shape surrounded by empty space (transparency). Use selection tools to cut out objects from photos or make shapes with drawing tools. You can then choose from a range of **Layer Styles** to add effects. A soft shadow effect will make the object appear as if it's floating above the underlying picture. **Layer Styles** can also be more complex, such as this 3D button, produced from a plain circle.

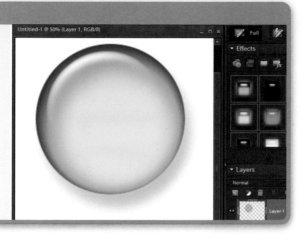

Flattening your layers

Image files containing multiple layers can only be stored in certain formats. Always save your work in Photoshop's native format (.PSD) so that everything will be present and editable when you load it back in. But to send the final image to anyone else, put it up on a website or add it to a Word document, you'll need to save it in a standard format such as JPEG (see page 23). The resulting file will look identical to the image you're saving but cannot be broken down into separate layers.

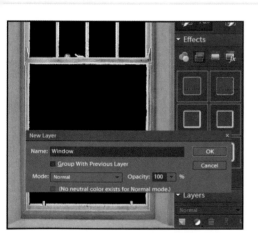

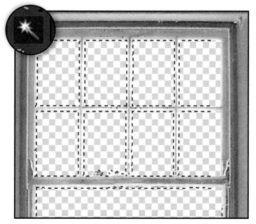

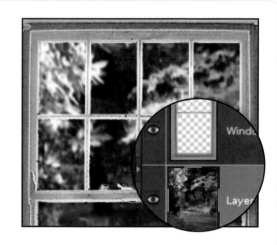

Build a simple photomontage

1 Run Photoshop Elements and select **Edit** from the **Welcome** screen. Using **Open** from the **File** menu, open a picture of a window taken at night. The panes appear black. To cut out parts of this picture, you first need to put it in a layer. Go to the **Layer** menu and choose **New**, then **Layer From Background**. In the dialogue box that appears, give your layer a name such as Window and then click **OK**.

Create transparent sections

2 Press **W** for the **Magic Wand Tool**. In the **Options** bar, set **Tolerance 8**, tick **Anti-aliased** and untick **Contiguous**. With this tool, click on any pane of the window to select all the black areas. (Find out more about how this works on pages 32 to 33.) Press **Delete** to erase the selected areas. A checkerboard pattern indicates that they're transparent. Press **D** to deselect.

Assemble the pictures

3 Open a picture of an outdoor scene. Press **V** for the **Move Tool**. Click on the outdoor photo and drag it onto the window, then position exactly. In the **Arrange** menu, choose **Send Backward**. The outdoor scene's layer moves behind the window layer, and the scene shows through the transparent panes. If necessary, click and drag the scene to reposition it independently within the window.

Liquify your photos

You can distort images in endless different ways with Photoshop Elements' **Liquify** feature, found under **Distort** on

the **Filter** menu. The idea is that your picture acts as if it's printed onto a sheet of soft modelling clay. By clicking and dragging on the picture with the various tools, you push, smear or twist the image. Use this for subtle adjustments, or to alter shapes radically – think of the Salvador Dalí paintings where solid objects become fluid – or, probably most fun of all, to tweak faces into caricatures.

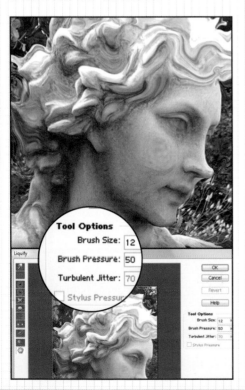

Special effects showcase

Discover the amazing possibilities of image-editing filters and effe

Adobe Photoshop Elements (see pages 14 to 15) comes with a huge range of special effects, which are often described as 'filters'. They work in a similar way to the basic colour and tone adjustments that you can see on pages 22 and 23, but filters enable you to make more dramatic and complex changes to your pictures.

An important aspect of filters is their ability to distort images. With simple colour or tone adjustment, the resulting image may appear different to the original but it would still match up if you laid one on top of the other. Only the colours are changed, not the composition of the picture or the shapes of objects within it. With many special effects this limitation is removed. The picture could be inflated to resemble a balloon. You can alter the image so that ripples radiate out from the centre as happens when a stone is thrown into a pond. Below and opposite you can see some examples of Photoshop Elements' filters, all found on the various sub-menus of the **Filters** menu.

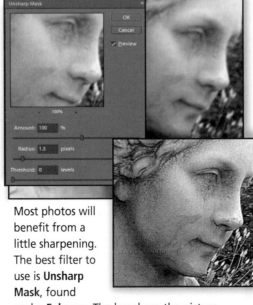

Most photos will benefit from a little sharpening. The best filter to use is **Unsharp Mask**, found under **Enhance**. The less sharp the picture, the higher you set the **Radius**, usually 1 to 4 pixels. Increase the **Threshold** to avoid sharpening fine detail, which can look grainy.

While sharpening gives the impression of greater detail, some filters work by removing detail. **Cutout**, found under **Artistic**, divides a picture into areas of flat colour. You can choose how many colours are used and how faithful the result is to the original image.

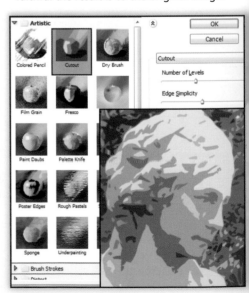

Diffuse Glow, found under **Distort**, gives any photo a romantic atmosphere. The edges of lighter areas are blurred so that they appear to glow. Simultaneously, the picture becomes grainier by adding random dots of darker and lighter colour.

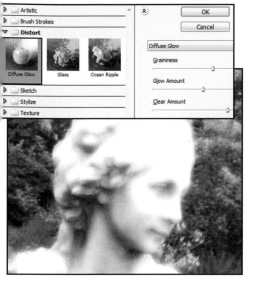

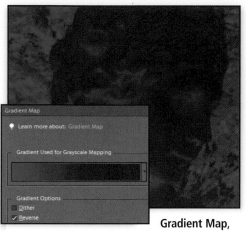

Gradient Map, found under **Adjustments**, allows you to make radical colour changes. Imagine you told a decorator to paint your house, and gave him the numbers of colours on a paint maker's chart. But he used the wrong chart and all the colours were different. **Gradient Map** has this effect on your picture.

The Lighting Effects filter

Photoshop Elements' **Lighting Effects** is a clever filter that can be used in two different ways. First, it can shine lights

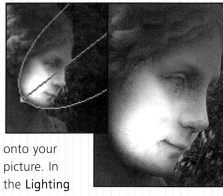

onto your picture. In the **Lighting Effects** box, each light is shown as an oval, and you can adjust its size and shape to control where the light falls. Secondly, the filter can combine the lights with a texture to create a 3D effect. The texture comes from a special kind of image called a 'channel'. As described on page 22, every picture consists of red, green and blue channels. Choosing one of these as the texture channel creates an unusual effect, turning detail in the picture into 3D bumps.

The **Pinch** filter smoothly distorts the whole picture to expand or contract the centre. With a positive setting, as seen here, the centre gets smaller. You'll notice how the size of the face is reduced compared with the hair. A negative setting would give the face an inflated appearance.

The **Sketch** sub-menu provides a range of black and white effects. **Photocopy**, for instance, simulates the output of a poor-quality photocopier, breaking up the picture into blobs of black on a white background. You can adjust the level of detail to make the copy fairly good or almost unrecognisable.

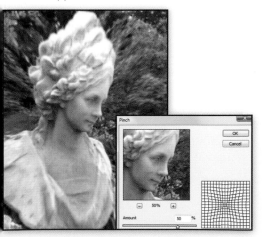

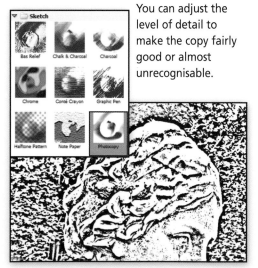

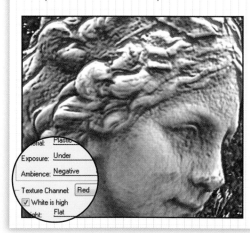

Brush up on your options

In order to use the **Brush Tool**, click its icon in the Elements toolbox on the left of the screen and

select the first option from the fly-out that opens, **Brush**. In the options bar at the top, click the black triangle by the brush sample to show other brushes.

Use the pop-up menu to switch between sets of brushes and then pick a brush from the list of samples. Adjust the size of the brush using the option to the right. Move the pointer onto your picture to see the current brush's size and shape.

Finally, the blending **Mode** determines how the paint will interact with the existing image. Choosing **Normal** covers up whatever you paint over. By switching to **Multiply**, for example, and reducing the **Opacity**, you can build up colour gradually as you might do with watercolour paints.

The tools of the trade
Explore Adobe Photoshop Elements' painting and drawing tools

Image-editing software has always had a tool called a 'brush', which has never behaved much like a real brush. Today, the **Brush** tool in programs such as Photoshop Elements (see pages 14 to 15) still falls short of providing an exact simulation of real painting, but it has a wide range of other uses too, many of them nothing to do with brushes. Whether you want to draw your own picture from scratch or add scribbled, painted, chalked or splashed elements to a photo, the **Brush Tool** has the answer.

Getting the result you want begins with browsing the sets of brushes supplied with

Among the many types of brush available, the **Calligraphic Brushes** are relatively simple, consisting of a plain hard-edged line or oval tipped at an angle. They can be used to mimic a traditional pen nib for line drawings or lettering. You can achieve the best results using a graphics tablet (see the box opposite).

the program. You can also tweak any brush extensively or even make your own custom brush (see page 31, opposite). When you're ready to paint, set the colour that you're going to apply by clicking the **Foreground Color** swatch at the bottom of the main toolbox and choosing from the **Color Picker**. Click on your canvas and, holding down the mouse button, drag to paint. Remember you can always use **Undo** (press **Ctrl+Z**) and try your brushstroke again.

Some of Elements' brushes are complex. The brush shown here is **Heavy Smear Wax Crayon**, from the **Dry Media Brushes** set, with **Hue Jitter** turned on so that the colour of the stroke varies continuously between the currently selected **Foreground** and **Background** colours.

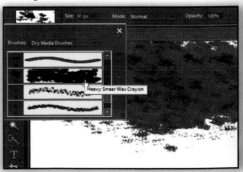

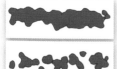

The **More Options** pop-up menu in the **Options** bar lets you customise a brush's properties. The samples, left, all result from drawing a rough horizontal line with the same basic brush (top). Each property has been altered in turn: **Spacing**, **Fade**, **Hue Jitter** (colour variance), **Hardness**, **Scatter** and then **Roundness**.

● Graphics tablets

A graphics tablet allows you to draw and paint in a more natural way than with a mouse. This is a plastic-coated pad that plugs into your PC and comes with a separate pen. The pen doesn't make any marks, but as you move it around the pad its position is reflected by the pointer on the PC screen. Your image-editing software will also respond to you pressing down with the pen, for example when applying a wider stroke or a stronger colour.

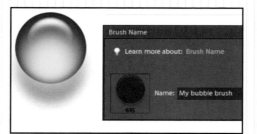

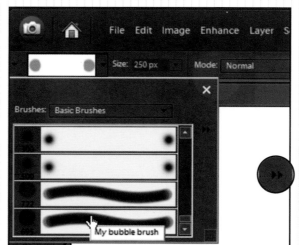

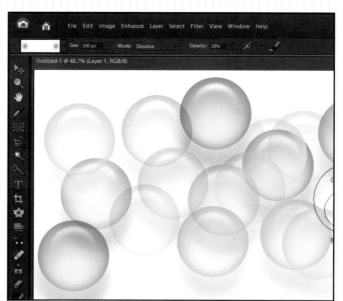

Create your own brush

You can create a custom brush in Photoshop Elements from any kind of image. One method is to make a selection around an interesting texture or object within a photo. Then go to the **Edit** menu and choose **Define Brush From Selection**.

Here's an example of a slightly different approach using a graphic created by a **Layer Style**, as described on page 27. Having applied a style to a shape within a layer, go to the **Define Brush** command on the **Edit** menu, which brings up a box where you can give your brush a name (see left, top). This is added to whichever set of brushes is currently selected in the **Options** bar.

Painting with your brush

Scroll to the bottom of the list and click on your brush. This is a good time to click the black double triangle symbol to the right and choose **Save Brush** from the pop-up menu so it's available the next time you run Elements. Now click and drag to paint. You'll probably need to use **More Options**, at the far right of the **Options** bar, to make adjustments to your brush. For example, if it just seems to make a solid line when you paint, increase **Spacing** and/or **Scatter**.

Photo surgery
Transform your photos with cutouts and cloning

Making selections

In Photoshop Elements and other image editors, you'll find the same basic selection tools in the toolbox. Simplest are the **Rectangular Tool** and **Elliptical Marquee Tool**: click and drag over your picture to select a rectangular or oval area (below).

The **Lasso Tool** lets you draw around an irregular area of your image by using the mouse. With the **Polygonal Lasso Tool** option (below), you can draw a series of straight or curved lines around the outline of a person or object, which doesn't demand such a steady hand.

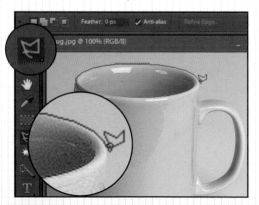

If an area you want to select is even in colour, click anywhere within it with the **Magic Wand Tool** (below) to select it all. A **Tolerance** setting controls how much of the area is selected. The **Magic Wand** is usually

set to **Contiguous**, meaning it selects a single area. Untick this option to select all areas of similar colour: one click separated the pale seed head below from its dark background.

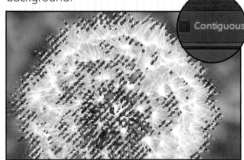

Using any of these tools makes a new selection, forgetting whatever area was selected before. But holding down a particular key adds the new area to the existing selection (**Shift** in Photoshop Elements) or subtracts it (**Alt**).

When you edit photos on your PC, you don't have to limit yourself to adjusting colour and lighting. You can move people around within a scene, erase objects or even combine several images to depict a fantasy scene.

The keys to this are the selection and cloning tools. When you make a selection, you outline an area of a picture, just like cutting around it with scissors. You select a particular person or object, copy the selection and paste it onto another photo using the **Copy** and **Paste** commands on the **Edit** menu. There are several ways to make selections, and to help you get what you want you can add areas to a selection or subtract from it, and so build it up bit by bit.

While a selection is active, any changes you make to the picture affect only that area. If you adjust the lighting or apply a special effect, everything outside the selection stays as it was. To edit the whole image again, you deselect. In Photoshop Elements you do this from the **Select** menu. You can also invert

In your image-editing program the currently selected area is shown as a flashing dotted outline. In this example, the background has been selected using the **Magic Wand Tool**. To add together areas of different tone or colour, click several times holding the **Shift** key.

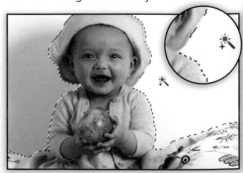

a selection, so everything that wasn't selected now is, and vice versa (also done from the **Select** menu).

Selections aren't so good for removing objects, as deleting a selection leaves a hole in your photo. But by using cloning you can paint one part of an image over another, for example to cover an unwanted building with extra sky or add a missing button on a coat.

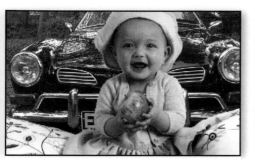

Once an area is selected, you can change it without affecting the rest of the picture. Here, the background has been replaced with a photo of a car using the **Paste Into Selection** command from Photoshop Elements' **Edit** menu.

The **Clone Tool** copies one area of an image over another. Click once on where you want to start copying from and then paint the copy where you wish. Here, the selection is left active, protecting the original baby, while extra copies of it are cloned into the background.

Using the Clone Tool

Imagine a paintbrush that picks up bits of an image from one part of your canvas to paint with elsewhere, either on the same layer or a separate layer. The 'source point', where the paint is picked up, and your brush remain in unison as you move around the screen.

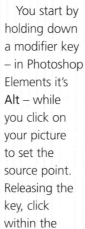

You start by holding down a modifier key – in Photoshop Elements it's **Alt** – while you click on your picture to set the source point. Releasing the key, click within the image where you want the cloned copy of the source point. As you continue to paint, by clicking and dragging, the area around the source point appears wherever you paint.

The palace above has been altered by cloning the left-hand section over the

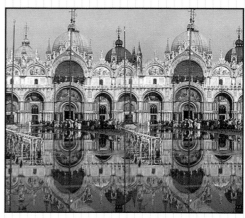

tower. The source point is set at the top of the first arch. Painting begins at the same point on the last arch and continues to the right.

You can also use blending modes (see page 26) with the **Clone Tool**. Below, the middle flower has been cloned using **Lighten**, so it replaces only the dark background.

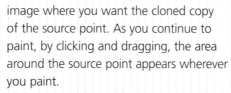

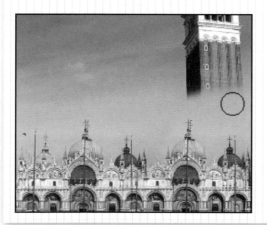

Scanning without frontiers
Put your flatbed scanner to more creative use

You can take a picture of almost anything with a digital camera, but it's less useful when you want to capture a document such as a page of a book or a craft collage. You may also have albums of photos you'd like to store and edit on your PC alongside your digital snaps. You can perform all these tasks with a flatbed scanner.

You can buy a scanner by itself or as part of a 'multi function' device that includes a printer. Each scanner comes with its own program to make scans, which can integrate closely with other Windows programs. That means a menu command for your scanner will be added to your image-editing software, such as Photoshop Elements (see pages 14 to 15). Programs may also be included with your scanner for other purposes, such as optical character recognition (OCR), which converts a scan of a printed page into text that you can edit

in a word processor. A flatbed scanner works in a similar way to a photocopier. You place the item you want to scan on a glass plate, and cover it with a hinged lid. When you start the scan, the 'scanning head', under the glass, moves from one end to the other. This builds up a picture that is sent to your PC. An image digitised in this way can be treated in exactly the same way as a photo taken with a digital camera.

Most flatbeds also allow 'transparency scanning', meaning that you can work from negatives or slides rather than prints. An extra lamp inside the lid shines light through the transparency. Standard 35mm film is very small, so your scanner has to work at much higher resolution than with a print, and you may not get such sharp results. Film scanners, which only take 35mm negatives and slides, provide even more detail than you'd get from a print but they're expensive.

Don't limit yourself to obviously scannable things. Think of your scanner as a general-purpose close-up camera and you'll get more value out of it. You can scan three-dimensional objects, as described in the workshop on the right, even your hands. But don't try your face, as the bright light would hurt your eyes, even if you could stay still long enough.

Scan solid objects

1 Run Photoshop Elements and choose **Edit**. Next, go to the **File** menu and click **Import**. The devices listed should include your scanner. Select it to open the software. You'll see the settings, and the scanner will warm up. Your scanner should start an automatic preview. If it doesn't, click **Preview** or **Preview Now**. If you haven't placed anything on the glass, the preview window will show the scanner lid.

Choose the right resolution

The best resolution for printing is 300 dots per inch (dpi). So if you intend to print your scanned image the same size as the original, scan it at 300dpi. But remember, if you want to print it larger, you need higher resolution – for example, 600dpi for twice the size. If you don't want to work out the scanning resolution yourself, most software lets you choose an output resolution, such as 300dpi for print, and then set the scaling factor or print size that you want.

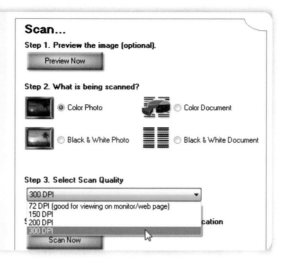

Scanning modes

Scanner settings (see the workshop below) should suit the material that you're scanning. For example, use the highest-quality colour setting for colour photos or objects, or greyscale for black and white documents such as text pages. Switch to **Transmissive** mode if you're scanning transparencies or film negatives. Colour and tone controls can normally be left on **Auto**. An **Unsharp Mask** option will make images appear sharper but may also reveal more dust, so leave sharpening to Photoshop Elements.

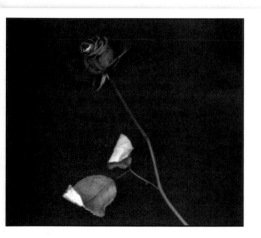

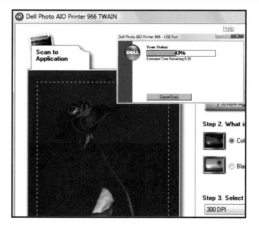

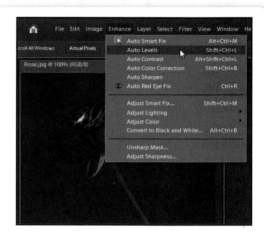

Arrange your object on the glass

2 Place your object carefully on the glass, face down. In this example it's a rose. Avoid stone or metal objects with sharp edges that could scratch the glass. You won't be able to close the lid, but you can place something over the object as a background. Here it's a black sheet of paper. Click **Preview** or **Preview Now** in the scanner software to see how your object looks and rearrange it if necessary.

Adjust scanning settings

3 Make sure all the settings are correct for your scan (see the boxes at the top of this page for some tips). Check that you're scanning in colour – a setting for colour photos will be fine – and at the appropriate resolution. In the preview window, click and drag to draw a box around the area you want to scan. When everything's set up, click **Scan** and wait for the scan to complete.

Edit and save the scanned image

4 The scanned image is displayed in Elements. Close the scanning window if it's still visible. Now use the image-editing functions to correct the image if necessary. For example, **Auto Levels**, from the **Enhance** menu, improves a dull scan. Go to **Save** on the **File** menu to save your scan. Choose the JPEG file format and use a high-quality setting to keep the detail you've captured.

A photo library in a flash
Organise your snapshots with Google's free Picasa photo manager

Quick fixes

The Picasa program includes a number of useful built-in effects and adjustments that you can apply to your photographs to make them more interesting. Here's

a photo of a bed of bright yellow flowers. Select the **Effects** tab in the left-hand window and then you can apply any of the effects by clicking on them once.

For more subtle changes, load a photograph into the main screen and then click the **Tuning** tab. Drag any of the four sliders left or right with the mouse to decrease or increase the effect.

Some photos are spoiled by poor composition. By clicking on the **Crop** button under the **Basic Fixes** tab you can 'draw' round the part of the image you wish to keep. The faded area around the shed will be removed when you click the **Apply** button.

You can add drama to a photograph in many different ways. The photo below was let down by a washed-out sky yet by clicking the **Effects** tab, choosing **Graduated Tint** and then selecting a new colour for the sky, the original has been improved dramatically.

Thanks to digital cameras, PCs are filling up with photo files. But digital cameras routinely assign them incomprehensible names such as DSC01557.JPG, so the more pictures you store, the harder it is to find the one you want.

Picasa, which you can download free from http://picasa.google.co.uk, organises all the photos and movies on your PC's hard disk in a flash, sorting them by date. It makes it easy to preview photos singly, or as part of a slideshow. You can move and copy photos between folders, set up labels (virtual albums that group together photos from many different folders), rate your photos using a star system, print them out, email them – Picasa resizes them

● Alternative image viewers

Adobe's Photoshop Album Starter edition, www.adobe.com/products/photoshopalbum/starter.html, offers many similar features to Picasa, and is also free. If space is tight, then IrfanView, free from www.irfanview.com, is a good choice; while FxFoto, from www.fxfoto.com, also offers features for fixing poor photos automatically. Even Windows Photo Gallery – part of the Windows Vista experience – does a good job , displaying a browser (below) when you double-click an image file.

automatically so that they won't take so long to send – and create a photo web page with them. Picasa turns photos into wallpaper for your desktop, and lets you create collages out of multiple photos, contact sheets for printing, even posters and slideshow CDs.

Picasa also includes powerful features for renaming whole groups of photos and has a fast, easy to use search feature. New photos are added automatically to Picasa's catalogue and, once the program is set up, you don't have to do anything. It's not as versatile a program as Adobe Photoshop, but Picasa offers excellent photo-fixing features. So, for example, you can crop photos, straighten them out, alter their colours and add special effects such as sepia, graduated tint and soft focus. There's even a special button called I'm Feeling Lucky that, when you click it, analyses the photo and applies those changes that Picasa thinks will improve the image.

Exporting from Picasa

Once you've edited a photo, you'll need to export it in order to make the changes permanent. Click on the thumbnail in the browser window that represents the picture and then click the **Export** button. Click the **Browse** button and choose where to copy the picture, drag the image size and quality sliders left or right with the mouse and then click **OK**.

1 Click the headings to open Picasa's standard Windows-style menus.

2 These large buttons control four key program features. Import loads pictures from a digital camera; Slideshow displays the photos in the current folder full size, one by one; Timeline displays a calendar-based carousel of your photos; Gift CD is a quick way of copying pictures to a blank CD.

3 Find photos by typing their filename, title or caption keyword into the Search box.

4 Click the Starred button to display only those photos that you've given a star rating. If you click the Movies button, then Picasa will display movies but not pictures. Click on the Uploaded button to only display items uploaded to web albums.

5 Drag this slider to display pictures based on the date you added them to the library.

6 Double-click a thumbnail to open it for editing.

7 Zoom in or out of pictures and thumbnails by dragging the slider left or right.

8 These buttons let you upload photos to a web album, email and print pictures, order prints via the internet, post pictures to your blog, create a collage, or export pictures.

9 The star button lets you tag your favourite photos, while the other two rotate pictures left or right by 90 degrees.

10 The Picture Tray displays any pictures you've currently selected, to export for example. Drag thumbnails here from the main browser window.

11 Hold allows you to add pictures from different folders to the Picture Tray, Clear removes them and Label lets you add a caption.

12 A list of folders on your PC that contain pictures. You can set Picasa to update the list manually, or automatically as images are added.

Digital cameras and the internet
Picture file formats and which ones work best on the web

Buying photo prints online

You have a choice how to produce photo prints from digital pictures taken with your camera. If you don't want to print them using your own printer, you can take your memory cards to a high street photo shop. There's also a third option: upload the picture files over the internet to an online photo shop.

These online shops are the internet equivalent of sending your old film cartridges in the post, except there's no chance of the films getting lost. Instead, you log on to the shop's website from your computer using a personal identification and password, and upload the picture files you want to be printed. Once you enter your credit or debit card details and complete the order, your picture files are printed at high quality onto photo paper and delivered to your address by post within a couple of days.

Unlike the old film approach, your picture files are maintained securely on the website until you choose to remove them, so reprints can be ordered instantly. You may also be able to pick from a range of photo products, from 6x4 inch prints to book albums and posters, and even mugs and t-shirts.

Once your pictures are downloaded from your camera to a computer, you have the option of uploading them to the internet in various ways, and for a number of purposes. Principally, the internet allows you to share your pictures electronically with other people. Anyone with access to the internet, no matter where that person lives in the world, will then be able to view your pictures instantly.

As well as creating albums to post on the web (see right) and sending selected pictures by email, you can incorporate scaled-down pictures into your own websites, whether at work or at home. Web browser programs such as Internet Explorer support only a limited range of picture file formats, so you need to choose the correct format for the job to help keep your website working at its most effective.

GIF

This was the first file format used on the internet and its high data compression allows for relatively small files. It isn't really meant for photographic images, so a photo saved to GIF format tends to look dotty or 'banded' where it should be smooth.

PNG

Pronounced 'ping', this file format combines the best of GIF and JPEG. It compresses flat colours brilliantly, just like GIF, and supports even photographic tones like JPEG but without affecting image quality.

JPEG

The most common format for digital photos – most cameras capture photos to JPEG. When you resize and resave a digital picture for the internet, be warned that increasing the compression settings tends to lose image detail. See also 'Size matters', page 23.

JPEG 2000

Also known as 'JP2', this emerging file format allows varying levels of compression across a picture, allowing you to preserve image quality where it's needed most. As yet, not many internet browser programs support JPEG 2000.

Understanding file sizes
Keeping photos small enough for all to share

If you want to put digital photos onto the web or send them by email, the size of the picture files is important. While a broadband internet connection can deal with large files effectively, not everyone who wants to view your pictures will have broadband access. Even when viewed through a broadband connection, a sequence of massive pictures may well slow the brower down to a crawl.

Where you need top quality, such as when uploading pictures to an online print shop (see opposite), keep picture files at their original size. But for use on everyday web pages you need to shrink the picture files, otherwise they may take forever to appear. The two main ways of making file sizes smaller are scaling and compression.

Scaling allows you to fit a picture into a reasonable space on-screen. A 4-megapixel camera, for example, will typically capture images that are bigger than most computer screens. Scaling the pictures down using Photoshop Elements (see page 7) will make them appear at a more appropriate on-screen size, and reduce their file sizes.

Picture compression identifies the pixel information in a picture and rearranges the data across similarly coloured areas to save space. The JPEG file format allows you to adjust the strength of picture compression on a sliding scale between file size and image quality. Although high compression can adversely affect the image quality, this is a fair sacrifice when putting pictures online for casual viewing in a web browser.

Just remember to save your rescaled and recompressed pictures with new filenames. Take care not to overwrite your originals.

With JPEG 2000, flat and blurry areas (A) are compressed strongly, while areas with precise detail (B) are preserved with light compression.

○ Sending photos by email

Attaching digital photos to email messages is simple enough, but it can make your emails enormous. This is because the email system uses a different form of data encoding than the World Wide Web, so that the size of file attachments swells up by between a third to a half. For example, a 1-megabyte picture may well become 1.5 megabytes once it's attached to an email. Remember, even if you have a broadband connection, your recipient might not. If you have pictures to share, consider creating a web album instead (see right).

Photo-sharing on web albums

Once you've taken a collection of pictures, it's a great idea to make them available to other people by putting them onto the internet as a web album. You can then create separate web albums for different events, such as one for a wedding, one to record an adventure holiday, and another for a school play. Web albums are cheaper and more convenient than reprinting dozens of photos and sending them to everyone by post.

A typical web album consists of a web page that presents the pictures as thumbnail images, often in a row or column that you can scroll through. When you click on any thumbnail, a larger version of that picture is shown along with a text caption.

Creating a web album is very easy to do, since programs such as Photoshop Elements provide a set of ready-made templates. All you need is some web storage space (every internet service provider gives you some as standard), then just select the pictures you want to include in the web album and choose a visual style from the templates.

Photo Projects

Disappearing act

Get rid of unwanted parts of a photo using Photoshop

The camera may never lie, but sometimes you wish it had been a little less truthful. That cathedral looks awe-inspiring – except for the telegraph wires crossing its frontage. Your car would appeal to any buyer – if you'd checked before photographing it and noticed what a passing pigeon had left on the bonnet. Fortunately, your PC can help make these little annoyances disappear.

PROJECT TOOLS: Photoshop Elements
SEE ALSO: Changing places and faces, page 62

● It's a cover up

The most powerful tool in your retouching toolkit is the **Clone Tool** (see page 33). And the key to successful cloning is having – in the same photo or even in a separate photo – background that you can pick up and 'paint' over the problem parts. When there's none available, a useful trick is to paste in an object that will hide the problem while preserving the composition. The same principles apply whether you're cleaning up a cityscape or removing unwanted objects from portraits or group shots.

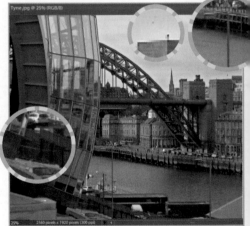

Decide what needs erasing

1 Run Photoshop Elements and in the **Welcome** screen click **Edit**. From the **File** menu click **Open** and browse to the image file you want. Click to highlight it and then click **Open**. Start by identifying the objects you want to remove. In this photo, clutter in the foreground distracts from the main scene, two large lampposts overlap the river and there are also some dark specks in the sky.

Adding and subtracting

You don't always have to start again if you've selected an area using the **Lasso Tool** or **Marquee Tool** and it isn't right. Hold down the **Shift** key and draw around an area to add it to the selection, or hold the **Alt** key to subtract an area. The cursor shows a plus or minus symbol to confirm this. Note that you have to hold the appropriate key down before you click.

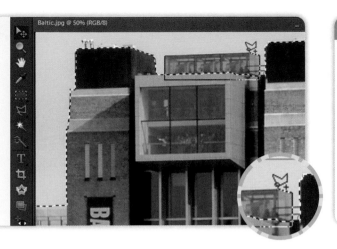

Healing spots

Another way to remove specks and blobs in a photo is to use Elements' **Healing Brush**. To activate it, click the sticking plaster icon in the toolbox on the left, then highlight the second sticking plaster tool from the fly-out options. Choose a small brush size and click on any isolated blemish to paint it out. The background texture is re-created automatically. This can be quicker than using **Filter**, **Noise**, **Dust & Scratches** when you have just a few marks to remove.

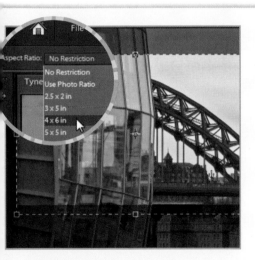

Set up the Crop tool

2 One way to remove unwelcome elements is to crop the photo to only the part of the scene that you want. Activate the **Crop Tool** by clicking C. In the **Options** bar at the top, click the **Aspect Ratio** option to pop up a menu of standard photo sizes, and choose one (see 'Preparing for printing', page 45). Leave the **Resolution** box blank. Click and drag on your photo to draw a crop box.

Careful composition

3 The shape, but not the size, of the box is fixed. If it's wide and you wanted your photo tall, or vice versa, click the double-arrow icon in the **Options** bar to swap the **Width** and **Height**. Drag the box to move it around and drag any of its corner handles to resize it. Try to crop off anything that you don't want in the picture, without spoiling the composition. Here, the grey blocks at the bottom can be removed.

Zoom in to examine blemishes

4 Double-click inside the box (or click the tick symbol) to crop the image. Next, examine your photo carefully for any small items that need removing. Here, there are black blobs in the sky at the top right. Zoom in to see items better by pressing Z for the **Zoom Tool**, then click repeatedly on the part you want to examine. To zoom back out, hold the **Alt** key and click.

● Resolution and the Crop Tool

When using the **Crop Tool** in Photoshop Elements, if you choose a preset **Aspect Ratio** (as in step 2), such as **4x6in**, and set a figure for **Resolution**, such as **300 pixels/inch**, the image will be resized as well as cropped. The resulting cropped image is converted to the new resolution by adding or removing pixels (see 'All about colour and resolution', page 22), and the process can't be reversed later without losing quality. In this project, you crop without setting the **Resolution** (step 2). Within the part of the photo that you keep, the pixels stay unchanged, so quality is unaffected.

A picture cropped to the same aspect ratio as the paper will fill the page when printed (near right). With a different aspect ratio, your print will have to be recropped or will show blank borders (far right).

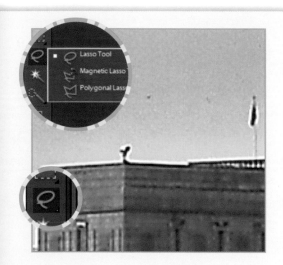

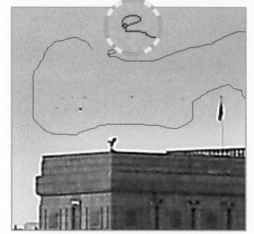

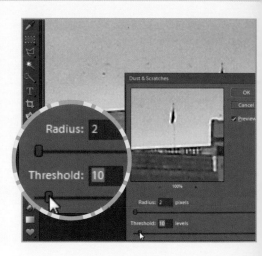

Rubbing out small blemishes

5 One of the specks is a distant flag that is best left. There's also what looks like a security camera. The others appear to be birds and need to be removed to tidy up the scene. Select an area around the specks. Click the Lasso icon, sixth down in the toolbox on the left. Ensure you have the first of the group of three icons in the fly-out selected, a square white dot indicates your selection.

Draw around the area

6 Click and drag on your photo to draw roughly around the area that needs cleaning up. Include all the specks you wish to remove, but avoid any small items or details that you want to leave in. Go all the way around the area, then release the mouse button. A flashing dotted outline shows that this area is selected. Now go to the **Filter** menu and choose **Noise**, then **Dust & Scratches**.

Make unwanted specks disappear

7 In the **Dust & Scratches** dialogue box, drag the **Threshold** slider to **0**. Set **Radius** to **0** as well, then increase it to **1** and look at the preview window above. Keep increasing until the unwanted specks disappear. Now increase the **Threshold**. This brings back the grain of the photo, so the selected area matches the rest. Set the level as high as possible without bringing back the specks.

⬤ Hitting the edge

While 'painting' with the **Clone Stamp Tool** (see step 11), you may find the cloned material you're applying suddenly stops, leaving a hard edge. This is because the point you've reached in the source area (where the 'paint' is being taken from) has reached the edge of the picture. Undo your painting (press **Ctrl+Z**) and choose a source point further away from the edge of the picture before trying again.

⬤ Preparing for printing

You can print any shape of picture on A4 paper and cut it out, but if you want to use pre-cut photo paper, or a digital photo printing service, it's best if your photo is the same shape as the paper used. The processes used by photo bureaux automatically enlarge the image to fill the photo paper, and any excess is cropped. So, when you edit your photos in Photoshop Elements, it makes sense to apply the shape or 'aspect ratio' of a paper size you're likely to use, to avoid losing the edges of your photo when it's printed (see the box on page 44).

Remove larger objects

8 Click **OK**. Zoom back out. Next, identify any larger objects that need removing from a fairly plain background. This picture would look better without the clutter at the bottom left, where a car and boat are seen below the main building. To remove them, cover them with water. First, protect nearby objects that you don't want to remove, in this case the edge of the building.

Protecting an area

9 Use the **Zoom Tool** as before to magnify the relevant area, then click back on the **Lasso** icon in the toolbox. Since the building has straight edges, ensure that the last of the three Lasso tools, the **Polygonal Lasso Tool**, is selected from the fly-out menu. In the **Options** bar, make sure that **Anti-Alias** is ticked. Click at the bottom of the wall, then release the mouse button and move up to make a straight line.

Invert your selection

10 Follow the wall, then click again. Continue beyond the area you want to remove, then take the line across the building and back down to the bottom, to outline a piece of the building. Double-click to finish. You now want to select everything except this area. To do this, choose **Inverse** from the **Select** menu. The flashing dotted border now runs along the edges of the whole picture and around the chosen area.

● Blank it out by filling

Removing something that seems straightforward may not be possible using cloning because there's nothing comparable in the photo to copy from. In this picture, you may want to remove the lettering from the banners to add your own message. But there are no plain banners to clone.

Instead, use the **Polygonal Lasso Tool** (see step 9, page 45) to draw around the banner, between the edge and the lettering. Before you start, go to the **Options** bar and set **Feather** to **3**, giving a soft edge. Having drawn your selection, press **I** for the **Eyedropper Tool**. Holding **Alt**, click on the banner to pick up its colour (almost black) as the **Background** colour, shown in the lower square at the foot of the toolbox on the left. Press **Delete** to fill the selected area with this colour. To blend in better with the photo, add **Noise** (see 'Without a trace' box, page 64).

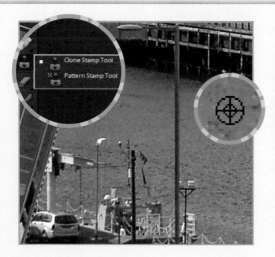

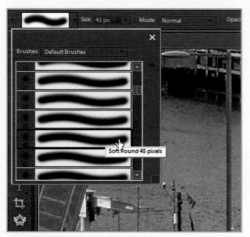

Pick a source point

11 Choose the **Clone Stamp Tool** from the toolbox on the left. Ensure the first of the two icons is selected (**Clone Stamp Tool**, not **Pattern Stamp Tool**). A square white dot confirms the selection. Tick **Aligned** in the **Options** bar at the top. Holding the **Alt** key, click to select your 'source point'. (For a full explanation see 'Image cutouts and photomontage', page 33.) Here, click on the river to the right.

Choose your brush

12 In the **Options** bar, a squiggle indicates the 'brush' you're going to use. Click the triangle next to this to show a list of brushes. Make sure **Default Brushes** is selected in the pop-up menu at the top, then scroll down the list and choose a plain soft brush (with fuzzy edges) large enough to paint your chosen area comfortably. The mouse pointer turns into a circle showing the brush size.

Clone over the unwanted objects

13 Click and drag to 'paint' over the unwanted objects. See the boxes on pages 45 and 47 for tips on problems when cloning and how to get around them. If necessary, paint over part of the area you want to remove, then choose a new source point and continue. Use **Zoom** frequently – you may want to zoom out to see more of the picture – but always check your work at **100%**.

● Running out of source

When choosing your source point (see step 11), try to make sure there's a sufficient area around it that will match the area you're attempting to cover. Sometimes you won't be able to find a single area to clone from that's big enough to cover the whole object you want to remove. In this case, cover a small area first, then choose a new source point to continue. But avoid 'dabbing' numerous tiny bits, as the result won't look realistic.

● Gently does it

By choosing a brush **Opacity** of **50%** or less you can gradually blend in cloned background for a more natural look. Don't be afraid to use a large brush – especially where the objects you're erasing are away from the main subject. Here, the source point was set by **Alt**-clicking on a patch of clear shoreline to the right of the objects, before painting over the shoreline to the left.

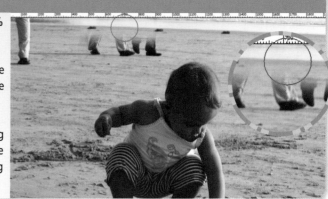

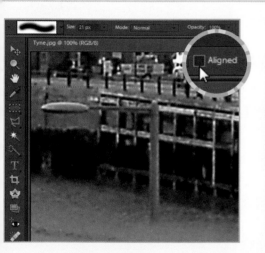

Removing tricky items

14 You'll need precise cloning where the background is more complicated, as here, where the top of the lamppost crosses the quayside. Press **Ctrl+D** to cancel the selection, then zoom into the relevant area. With the **Clone Stamp Tool**, go to the **Options** bar, choose a smaller soft brush and untick **Aligned**. Look for an object similar to what would be behind the item you want to remove.

Match your source and target points

15 In this case, the timbers behind the lamppost match those to the right. Holding **Alt**, choose a source point that's clearly identifiable: here, it's where the timbers cross. Release the **Alt** key. Click on the equivalent point where you want to copy the source area (the place behind the lamppost where the timbers would cross) and drag to start painting the source material over the unwanted object.

Paint with one stroke

16 If the clone isn't perfectly positioned, undo (press **Ctrl+Z**) and try again. Because you unticked **Aligned**, the **Clone Stamp Tool** starts painting from the original source point (where you **Alt**-clicked) each time you click. Once it fits in correctly, paint as much as possible in one stroke. Where the underlying background changes, choose a new source point. Remove other objects using the same methods.

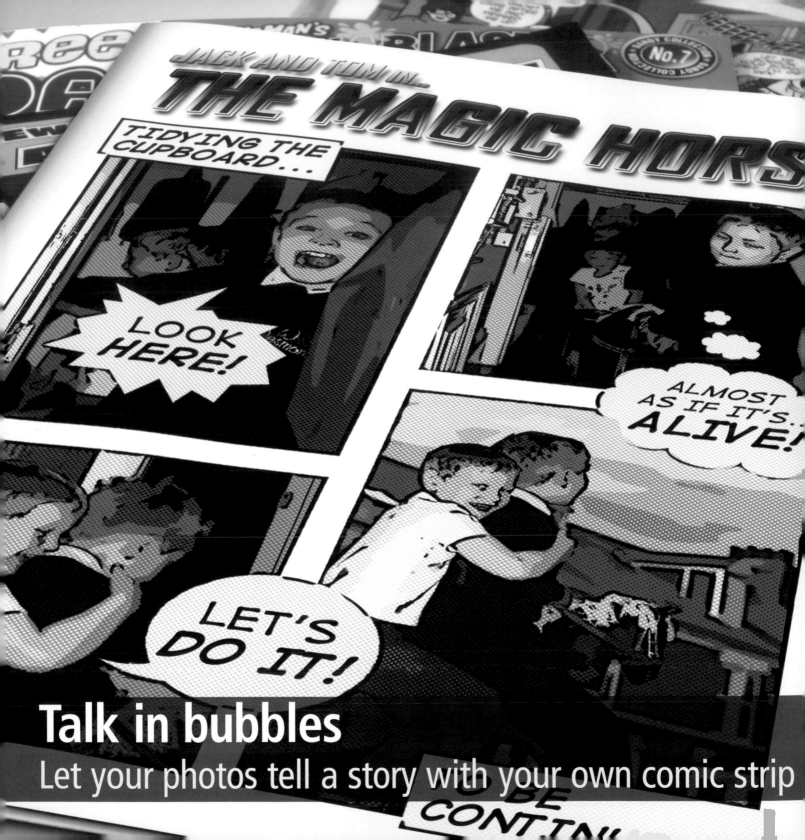

Talk in bubbles
Let your photos tell a story with your own comic strip

Blam! Kerpow! Comics provide a fresh and direct way to present words, pictures and ideas, and are popular both with children and adults. It's easy to create your own comic strip, featuring members of your family, or telling the story of a special event. Using image-editing software such as Photoshop Elements, you can turn ordinary photos into comic-style artwork and incorporate them into layouts that look just like the real thing, complete with comic-strip frames, captions and speech bubbles. Your finished layout can be printed out or saved as a graphics file to email to friends and relations. To get started, all you need to do is think of a storyline and take a few pictures to illustrate it. Or maybe you'd like to turn your holiday or family-gathering snaps into cartoon-strip format – the possibilities are endless.

PROJECT TOOLS: Photoshop Elements ● Digital photos

Metric or imperial?

When entering measurements in Photoshop Elements, use either inches or centimetres as you prefer: type in after the number for inches, or cm for centimetres. All conversions are made automatically. This project is shown on A4 paper using metric measurements (centimetres). If you have an A3 inkjet printer, it can be adapted to a larger paper size – to frame as a poster, for example – when you come to print out the comic strip.

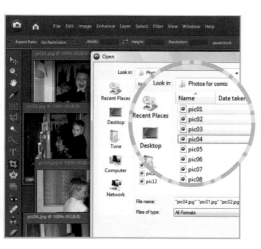

Start with a blank canvas

1 Here we're making a comic strip from four photos. Run Photoshop Elements and choose **Edit**. Go to **File** and click **New, Blank File**. In the **New** box, choose **International Paper** from the **Preset** menu and **A4** from **Size**. Make sure the **Color Mode** is **RGB Color** and **Background Contents** is **White**. Click **OK**. Go to **File**, choose **Open**, browse to the photo folder, hold the **Ctrl** key and click to highlight all four. Click **Open**.

Crop your first picture

2 Edit your pictures now if you need to. (The fourth image will be altered, as explained in 'Faking a photo', page 55.) Then click on your first photo and press **C** to activate the **Crop Tool**. In the **Options** bar at the top, set **Width** to **9cm** and **Height** to **13cm**. Set **Resolution** to **300 pixels/inch**. Now click near the top left of the photo and drag to draw a crop box around the area you want to use.

Add a picture to your layout

3 Drag the crop box to move it around, or adjust its size using the corner handles. When you're happy with it, double-click within the box. The picture is cut down to this area and automatically resized to the dimensions and resolution you entered. Choose the **Move Tool** from the top of the toolbox on the left (or press **V**). Click on the photo you just cropped and drag it across onto your blank document.

Planning pays

Plan your comic strip before you start. With a pencil and paper, sketch a 'storyboard' showing what will happen in each frame. Then get your actors together and take your photos using a digital camera. Use a good-quality setting with high resolution, and make sure you get your subjects in focus, so that your pictures will look clear even after you crop them down. Small details won't show up in the finished comic, so keep your scenes simple and direct your characters to use their bodies and faces to reflect what's going on in the story.

A coloured background

The comic strip in the project below has a white background, which means you can print it on almost any printer, because the colour doesn't have to go right to the edge. If your printer offers 'borderless' printing, you may prefer a coloured background. After creating your blank canvas (step 1), choose **Fill Layer** from the **Edit** menu. Set the **Blending** options to **Normal**, **100%**. Under **Contents**, choose **Color**, then pick a colour. Click **OK** in each box.

Snap your pictures into place

4 Drag the picture to place it near the top left of the page, leaving a gap at the top. Click on your second photo, and switch back to the **Crop Tool** (press C). This time, set both **Width** and **Height** to 9cm. Crop the photo as before and drag it onto your layout using the **Move Tool**. Click on it and drag it close to the picture you placed previously. Let the photo snap into place, neatly lined up.

Add the remaining pictures

5 Click on your third photo and use the **Crop Tool** with the same dimension settings, **9x9cm**, to cut it down. Use the **Move Tool** to add it to your layout as before, snapping it to the bottom edge of the first picture. Repeat for the fourth photo, this time setting the dimensions back to **9x13cm**, as for the first picture. When you snap this into place, you should have a neat rectangle of images.

Divide your frames

6 Click the **Marquee** icon in the toolbox and select the **Rectangular Marquee Tool** option. Set **Feather** to 0. Click the **Mode** option and choose **Fixed Size**. Set **Width** to **0.75cm** and **Height** to **25cm**. Now click anywhere on the layout and drag to draw and position a fixed-size rectangle. Centre it exactly on the vertical line where your pictures meet, overlapping at the top and bottom.

Smooth lines and curves

Photoshop Elements' **Text Tool** and **Shape Tool** create special layers in 'vector' format. These can be edited or resized without affecting the quality of their appearance. If you try to apply an adjustment, filter or effect to one of these layers, a box will warn you that it first has to be 'simplified' – converted into a normal image layer. After this you can't edit text, and resizing shapes may make them look fuzzy. So, if you have more editing to do click **Cancel**.

Image editing and memory

Photoshop Elements uses your PC's memory (RAM) and hard disk while it works. If it runs out of space, an error box appears. Try closing any other images in the Window menu, and any other programs shown in the Windows **Task Bar**. To free more memory, go to the **Edit** menu and choose **Clear**, **All** (this disables **Undo**). If this doesn't help, your hard disk may be full. For advice, go to Windows' **Start** menu, choose **Help and Support**, and enter disk too full in the **Search** box.

Create a white bar

7 In the **Layers** palette, shown on the bottom right of the screen above, you have five layers (choose **Layers** from the **Window** menu if you can't see it). Four contain the pictures you added, the fifth layer is the plain **Background**. Click the **Background** layer to highlight it. Go to the **Layer** menu and choose **New**, then **Layer via Copy**. A new layer appears in the **Layers** palette, called **Layer 5**. Click this and drag it to the top of the list, above **Layer 4**.

Angle the bar

8 The new layer contains a copy of the part of the **Background** layer within the selection made in step 6, making a white bar. Go to the **Image** menu and choose **Transform**, then **Skew**. Handles appear around the bar. Place the mouse pointer over the top middle handle, so it shows a grey triangle with arrows pointing to the left and right. Click and drag a little way to the right. The white bar skews over.

Duplicate the bar

9 Don't skew it too much, because the shape still needs to cover the edge between the pictures along its full length. To make sure it does so, click within the shape and drag it to the left a little. Finish by clicking the green tick icon below the white bar. Holding down the **Alt** key, click the white bar again and drag it to one side. This makes a copy of it in a new layer, called **Layer 5 Copy**.

Comic-book jargon

Comic artists have their own jargon for the elements of a page. The pictures making up your story are 'frames'. The people in them are 'characters'. Text is 'lettering'. Shapes containing words that your characters say or think are 'bubbles', usually 'speech bubbles'; 'thought bubbles' are cloud-shaped. The words they contain are 'dialogue'. Lettering that represents actions – Splat!, Blam!, Kaboom! – is called 'sound fx'. Any other lettering is referred to as a 'caption'.

Organising your layers

Once you build up layers in your Photoshop Elements file, you'll need some tricks to keep them properly arranged. To select a piece of text or artwork in a layer and move it about the canvas, press **V** to activate the **Move Tool** and, in the **Options** bar at the top, ensure **Auto Select Layer** is ticked. Now click on the item you want and drag to move it. To move several items at once, hold **Shift** while clicking on them to select all their layers. To put a new item behind an older one, either press **Ctrl-[** to move it back, or drag its name further down the list in the **Layers** palette.

Rotate the copy

10 Place the mouse pointer slightly outside a corner of the new bar, so it shows a turning arrow symbol, then click and drag to rotate the bar. The amount of rotation is shown in the **Options** above: make it about **85** degrees. Drag the bar into place so its left-hand end covers the horizontal edge between the two pictures on the left. Click the tick to finish. Switch back to the **Marquee Tool** (press **M**).

Cut the bar in two

11 In the **Options**, set the **Mode** back to **Normal**. Click and drag to draw a rectangle around the right-hand end of the bar you created, starting within the gap made by the vertical bar in the middle. Hold down the **Ctrl** key (the mouse pointer shows scissors). Click within the rectangle and drag it upwards until this section of the bar covers the edge between the two right-hand pictures.

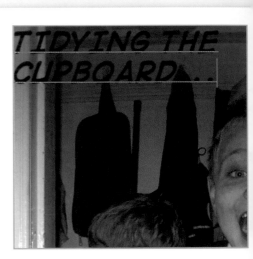

Write some text

12 When the bar is in the correct position, press **Ctrl+D**. Click the **Text** icon in the toolbox and select the **Horizontal Text Tool**. In **Options**, choose a font (see 'Finding comic-book fonts', page 53). Set the font size to about **18pt**. Press **D** to set the default colours (black on white). Click near the top left corner of your first frame and type a few words to begin the story. Press **Return** to move onto a new line.

● Finding comic-book fonts

Despite its name, the Windows font 'Comic Sans' looks nothing like the lettering in comics. You can get better fonts, many free, from websites such as www.blambot.com, www.pizzadude.dk and www.fontdiner.com. Find a suitable font and choose PC TrueType (TTF) format. When you click to download the font, a warning box appears. Click **Save**, and choose a place to put the file, such as **Documents**. From **Computer** on the **Desktop**, go to this folder and double-click the file you've downloaded. If it's a 'zip' file, click **Extract All Files** to run the **Extraction Wizard**, then click **Next** and **Finish** to convert it into a folder containing fonts. From the Windows **Start** menu, go to **Control Panel** and double-click the **Fonts** icon. From the **File** menu choose **Install New Font**. The **Add Fonts** box appears. Under **Folders**, select your folder to get a list of fonts. Highlight any font you want, then click **OK** to import it.

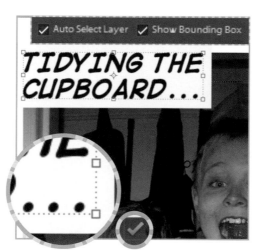

Add a text box

13 Click the tick in the **Options** bar to finish. Select the **Shape Selection Tool** icon in the toolbox, and click the **Rectangle Tool** option. Click the triangle to the right of the **Color** option to pop up a set of colour swatches. Choose **Pastel Yellow**. Click and drag to draw a rectangle slightly larger than your text. Then hold the **Ctrl** key and press [(left square bracket). The rectangle moves behind the text.

Arrange your graphics

14 Press V for the **Move Tool**. In the **Options** bar, tick **Auto Select Layer** and **Show Bounding Box**. Drag the corner handles of the coloured rectangle to adjust its size. Click the green tick icon below the box to finish, then click on the text and drag to reposition it if necessary. If you need to resize the text, hold **Shift** while dragging a corner handle. Next, switch back to the **Shape Tool** (press U).

Create a speech bubble

15 From the **Shape Tool** fly-out select the **Custom Shape Tool** option. Click the **Shape** option from the option bar (found at the top of the screen) to display the **Shape Picker**. Click the double triangle at the top and choose **Talk Bubbles**. Pick a shape and choose another pastel colour. Click and drag to draw a bubble over your first picture. Use the **Move Tool** (press V) to resize and/or rotate it. Reset the default colours (press D). Use the **Text Tool** to add some words.

● Online resources

When you want to take your comic art further, plenty of help is available on the internet. Most of the tutorials available are based on the full version of Photoshop but most techniques will also work in Photoshop Elements. For example, www.polykarbon.com has many expert tips on cartoon design. If you're interested in learning to draw comic strips yourself, rather than working from photos, you'll find several helpful tutorials at http://neondragonart.com/dp/tutorials.

● Getting the text right

When lettering your comic strip, take a couple of small actions to help make the text look good. Use the buttons in the Photoshop Elements **Options** bar to align the text appropriately, usually to the left for captions and to the centre for bubbles. Next to these buttons is the **Leading** setting, here **Auto**. Use this to adjust the vertical space between lines within a block of text. For comics, this should be 'tight' – about the same measure as the font size.

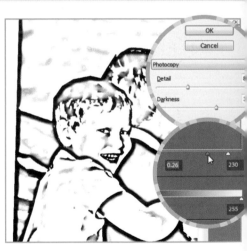

Add more bubbles

16 Repeat steps 12 to 15 to add bubbles and narration to your other pictures. When finished, look at the **Layers** palette. Layers containing text, called 'type' layers, are identified by a letter 'T'. Drag each of these to the top of the list so that all the type layers are at the top. Then click on the highest layer that isn't a type layer. Hold **Shift** and click the **Background** layer to select all the layers in between.

Prepare a comic-book art effect

17 In the Layers menu, choose **Merge Layers**. Everything except the text is now on the **Background** layer. In the **Filter** menu, choose **Blur, Smart Blur**. Set **Radius** 20, **Threshold** 32, **Quality High, Mode Normal**. Click OK. This smoothes the pictures. Choose **Duplicate Layer** from the **Layers** menu. Type Outlines and click **OK**. In the **Layers** palette, change blending mode from **Normal** to **Multiply**.

Draw black outlines

18 Press D for the default colours. From the **Filter** menu, choose **Sketch, Photocopy**. Adjust the sliders until a thick black line outlines the main features: try **Detail 8, Darkness 30**. Click **OK**, then press **Ctrl+L** to show the **Levels** box. Tick **Preview**. Drag the white slider left until the fainter lines disappear; drag the grey slider halfway up to it. Click **OK**. In the **Layers** palette, click on **Background**.

● Faking a photo

Anything you can't photograph, you can fake. In this project, to make the boys fly, they're cut out and overlaid on a photo showing rooftops. The comic art effect (steps 17 to 20) will hide any rough edges, so the cutout needn't be perfect. In Photoshop Elements, click the **Lasso** icon in the toolbox and select the **Polygonal Lasso Tool**, which draws straight lines. Click at the bottom left of the area you want, and move to draw a straight line. Position this and click again. Continue all the way around, then double-click to finish.

Press **Ctrl+J** to copy this area into a new layer. Open the rooftop photo, then press **V** for the **Move Tool**, and drag this photo onto the other. Press **Ctrl-[** to put the rooftops behind the boys. Use the box around the photo to position and resize it. Double-click to finish, then choose **Flatten Image** from the **Layers** menu.

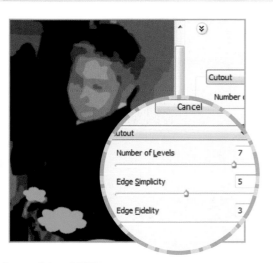

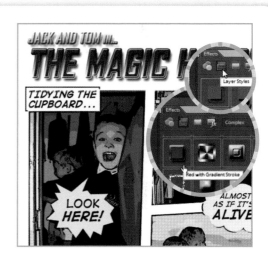

Create blocks of colour

19 From the **Filter** menu, choose **Artistic**, then **Cutout**. Set **Number of Levels** to **7** and **Edge Fidelity** to **3**. Adjust **Edge Simplicity** to divide the picture into simple but recognisable blocks of colour: try **5**. Click **OK**. In the **Layers** palette, right-click the **Background** layer and use **Duplicate Layer** as in step 17. This time, in the **Duplicate Layer** box, call the new layer Dots. Click **OK**.

Using halftone effects

20 In the **Filter** menu, choose **Adjustments**, **Equalize** to even out the tones in this copy of the artwork. In the **Layers** palette, change the new layer's blending mode to **Pin Light**. In the **Filter** menu, choose **Sketch**, **Halftone Pattern**. Set **Size** to **3**, **Contrast** to **25** and **Pattern Type** to **Dot**. Click **OK**. This simulates the halftone dot pattern that is found in cheap printing. Click the top layer in the **Layers** palette.

Finish with a title

21 Switch to the **Text Tool** (press **T**). Click at the top left of the page and type a title. Adjust the font and size. Choose a dramatic font: here it's **Agency FB**. In the **Effects** palette, select **Layer Styles**, then choose a suitable effect. Click it to style your text. Save your comic strip in Photoshop (.PSD) format for future editing, perhaps to add new pages. If you want to send it to others, for example via email, save it as a **JPEG** file.

Say it big

Grab attention by creating your own posters

It's simple to design a poster using Photoshop Elements, and the end result will get plenty of attention, whether it's advertising a club or school event, promoting a business or just showing off your digital photos. Although your printer will normally be limited to A4 paper, you can split your artwork onto several sheets and stick them together to make a full-size poster.

PROJECT TOOLS: Photoshop Elements • High-resolution digital photos
SEE ALSO: Changing places and faces, page 62

● Use the space well

Pictures don't have to start off big to fill a poster. In this project, a picture is mirrored to make it fill more space (see below). Or you could use several images and position them next to each other. Also try filling one-third or two-thirds of the poster with a picture or several pictures arranged to fill a rectangle, then placing your text neatly within the remaining white space.

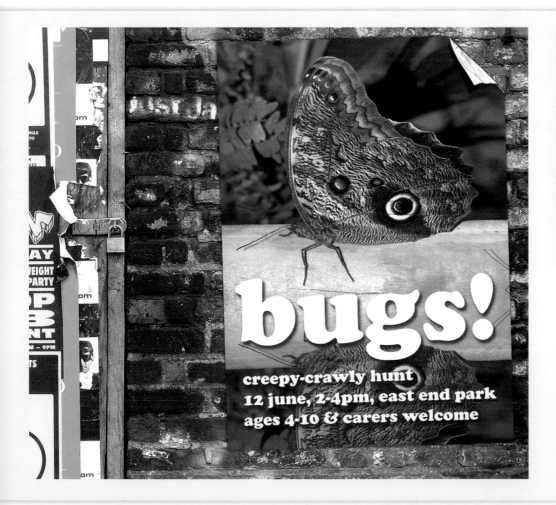

Choose a size for the poster

1 Run Photoshop Elements and click **Edit** from the Welcome screen. Click **File, New** and then **Blank File**. In the dialogue box that appears, set the size and resolution of your poster. Click the **Preset** menu to pop up a list of paper options, we chose **International Paper**. Then click the **Size** menu and choose **B3**. This is 50cm (20in) high, large enough to grab attention, and you can print it yourself using four sheets of A4 paper.

Text and typography

A poster isn't a book, so you don't necessarily have to follow the usual rules of typography and grammar. In this project, all the poster text is in 'lower-case' or small letters, with no initial capitals for names or the first word of a sentence. It looks less formal and works well with the friendly Cooper Black font (see step 13). But keep things consistent – if you omit capitals then do so throughout.

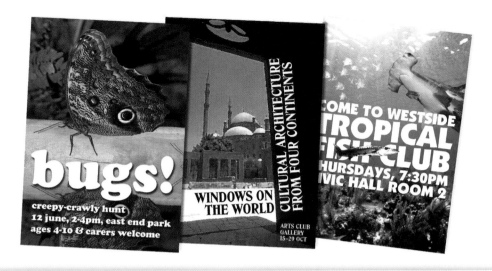

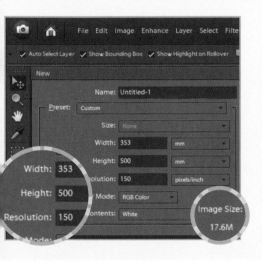

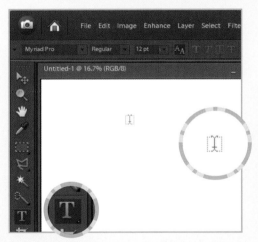

Fine detail is unimportant

2 When you choose **B3**, the correct width and height appear below. The resolution is set to **300 pixels/inch**, the standard for high-quality printing. As displayed at the bottom right of the box, this makes a very large file – more than 70Mb. But you don't need so much detail because posters are usually viewed from a distance. Change the resolution to **150 pixels/inch** to make a smaller, 17.6Mb file.

Get writing

3 Make sure the last two options under **New** are set to **RGB Color** and **White**, then click **OK**. Your blank poster appears on the screen. Start by writing the main text that you are going to have on your poster. To do this, click the **Text Tool** icon in the toolbox on the left of the screen. The mouse pointer changes to a text cursor similar to that used in other Windows programs.

Set the text size

4 In the **Text Tool** options fly-out, make sure the first of the four text tools is selected. A square white dot indicates this. Don't worry about which font is selected — you can change this later — but do set the size. This is measured in points (pt). For a large headline, try **200pt**. The pop-up menu only shows smaller sizes, so double-click on the number shown and type 200 in its place.

Keep it smooth

When using the **Text Tool**, make sure the **Anti-alias** button ('AA') in the **Options** bar is highlighted so it smoothes the edges of letters. If they still look rough, check the zoom level shown in the title bar of your image. If it isn't 100% multiplied or divided by a multiple of two – for example, 25%, 50%, 100% or 200% – the display is imperfect. To zoom in or out, hold **Ctrl** and press plus or minus.

Perfect curves every time

Avoid resizing an image more than once or making it too large since this will degrade its appearance. The software has to re-create the image's pixels each time you resize, and that process isn't exact. Text is different. It's stored as 'vectors', which are geometric descriptions of lines and curves. Photoshop Elements converts these to pixels at whatever size the text appears on your canvas. No matter how you resize the text, it always looks perfect.

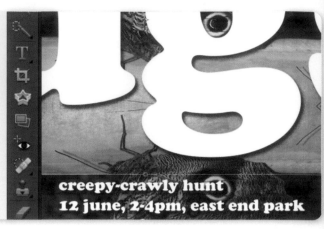

creepy-crawly hunt
12 june, 2-4pm, east end park

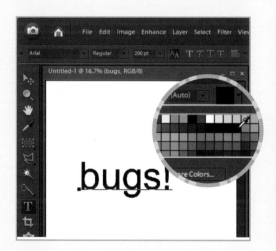

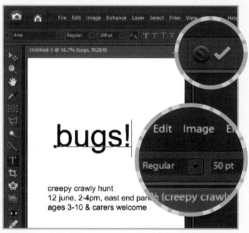

Type the headline

5 At the far right of the **Options** bar, the **Color** box should show black. If not, click the triangle to show a menu of colours, and pick **Black**. Click somewhere on the left of your blank canvas to start typing. Enter a concise headline for your poster, ideally a single word that will grab attention. Adding an exclamation mark is an easy trick to make a headline more exciting.

Add more text

6 Click the green tick icon at the right of the **Options** bar to finish entering text. Then click lower down the canvas to start a new piece of text. Before entering it, change the text size at the top to a lower setting, say **50pt**, and type in the main text of your poster. Press **Return** whenever you need to move on to a new line – this won't happen automatically as it would in a word-processing program.

Time for a picture

7 Click the tick again to finish. Now go to the **File** menu and choose **Open**. In the **Open** dialogue box, select an image file and click **Open**. Make sure you can see both your poster and the picture (see page 63, step 2), then activate the **Move Tool** – click its icon at the top of the toolbox on the left, or press **V**. Click on the picture and, holding the mouse button down, drag onto the poster, then let go.

● Fine-tune special effects

Photoshop Elements includes many preset **Layer Style** effects, like the one used in step 14 to create a shadow. These can all be customised. After applying a layer effect (see step 14), go to the **Layer** menu and choose **Layer Style**, then **Style Settings**. The options available will depend on the **Layer Style** chosen. For example, you can change the direction of a shadow by altering the **Lighting Angle** or how far away it falls using **Distance** under **Drop Shadow** (see right).

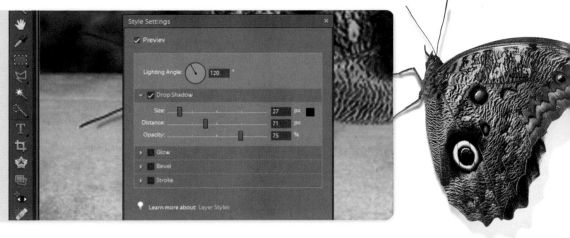

Size is important

8 Because your poster is big, the picture may appear small. To make it larger, drag any of its corner handles (hold **Shift** to preserve the picture's shape). Doing so reduces the picture's quality on the finished poster, so avoid increasing its size by more than about half. This butterfly picture would look poor if resized to fill the whole poster. But don't just leave a small picture in the middle, as it will look lost.

A careful arrangement

9 Instead, arrange one or more pictures creatively. Here's a good solution for this example. First, resize the butterfly picture so that it fills the width of the poster, remembering to hold down the **Shift** key to retain its proportions. Go to the **Image** menu and choose **Rotate**, then **Layer 90° Left**. When you're satisfied with your arrangement, **double-click** on the picture (or click on the green tick icon under your image) to confirm your changes.

Mirror the picture

10 Holding the **Alt** key, click near the top of the picture and drag down the canvas to make a copy of the picture, which will snap into place directly below it. Go to **Image**, **Rotate** and **Flip Layer Vertical** to mirror the picture. In the **Layers** palette on the right, you now have several layers: the blank white **Background**, two text layers, the original picture ('Layer 1') and the upside-down copy ('Layer 1 copy').

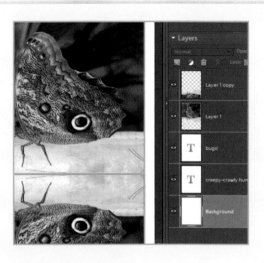

● Printing a multi-sheet poster

By printing your poster across multiple sheets of A4 paper you can produce posters of any size. From the **File** menu, choose **Print**. In the **Print Preview** box, set **Print Size** to **Actual Size**. Click **Page Setup**. Make sure **Paper Size** is A4, then click **Printer**. Select your printer, then click **Printer Preferences** to see your printer's options. Look for 'poster' or 'tiling'. In the example right, you click the **Advanced** tab, set **Layout** to **Poster**, then click **Select Pages to Print** and **Select All**. Click **OK** in each box, then **Print**.

If your printer lacks this facility, go back to the **Print Preview** box and untick **Centre Image**. Click the preview of your poster and drag it so the top left corner is about 1.5cm (0.6in) from the top left of the box, indicated by the **Position** setting. Print this, then go back to **File**, **Print**. Now drag the poster so the top right is visible with a similar margin. Repeat for the bottom right and bottom left quarters. After printing, arrange your four sheets to make up the poster, then glue the overlaps together. Use scissors or a craft knife to trim the edges.

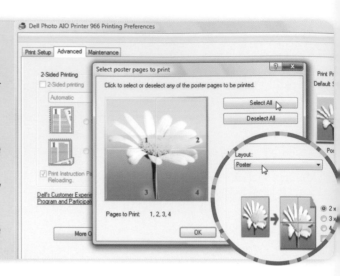

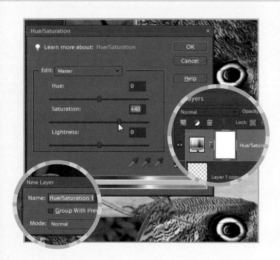

A splash of colour

11 The butterfly looks a little drab. Go to the **Layer** menu and choose **New Adjustment Layer**, then **Hue/Saturation**. In the **New Layer** dialogue box, leave all the settings as they are and click **OK**. In the **Hue/Saturation** dialogue box, tick the **Preview** option. Move the **Saturation** slider to the right until the colours in the image look brighter. Don't overdo it, or the colours will become unnatural – about +40 should be enough. Click **OK**.

Get in order

12 An adjustment layer (see 'How layers stack up', page 26) affects all the layers below it. In the **Layers** palette, the **Hue/Saturation** adjustment layer is at the top, so it applies to both copies of the butterfly. Your text layers are at the bottom, so they're currently invisible on the canvas. Click each text layer in turn and drag it to the top of the list. Now you can see the text and it's unaffected by the saturation change.

Style your text

13 Click your headline layer, then press **T** for the **Text Tool**. Change the font and size in the **Options** bar. Choose **Cooper Black**, or any bold, clear font. From the **Color** pop-up menu, choose **White**. Switch to the **Move Tool** (press **V**). Use the bounding box to size and position your text. As with pictures, hold **Shift** while dragging a corner to resize without distortion. Click the green tick below the text box to finish.

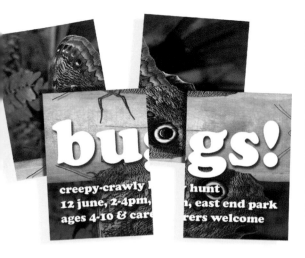

● Saving your poster

Using **File**, **Save**, save your work as a **Photoshop** file, which includes all your layers. This file will probably be larger than the 17Mb quoted in step 2. If you want to send your poster to someone else, or keep a backup copy of the finished result (without layers), go to **File**, **Save As** and choose **JPEG** format. Click **Save**. The **JPEG Options** box appears. Under **Image Options**, set **Quality** to 10. Click **OK** to save the file.

Add shadowing

14 To make the text stand out, add a 'drop shadow'. With the text tool selected, click the text layer. Then, in the **Style** drop-down menu on the options bar, click the double-headed arrow and select **Drop Shadows**. Click the example labelled **Noisy** to add a fuzzy shadow. Click your other text layer in the **Layers** palette and repeat from step 13 to style and position it, and add a shadow.

Make the text stand out

15 At the bottom of the poster, the picture still makes the text hard to read. To fix this, click the upper butterfly layer (**Layer 1 copy**) in the **Layers** palette, then go to the **Layer** menu and choose **New Fill Layer**, then **Gradient**. Click **OK** in the **New Layer** box. In the **Gradient Fill** box, click the triangle to the left of the **OK** button to pop up a menu. Pick the third example, called **Black, White**.

Darken your picture

16 Click **OK** to create a 'gradient fill' layer. To make this darken the butterfly picture instead of hiding it, click **Normal** at the top of the **Layers** palette to change the fill layer's blending mode. Choose **Linear Burn**. The effect is still too strong, so click the arrow to the right of **Opacity** and reduce the level to 30% by dragging the slider that pops up. Finally, save your poster (see box above).

Faking it

Use some image-editing magic to send granny to the moon

By merging parts from different photos you can create scenarios that would be impossible in real life. All you need are some photos and a bit of imagination. Thanks to image-editing layers, you can adjust, resize, fade or colour each element of your composition independently, then fit them all together seamlessly. The resulting photomontage – whether it's gran on the moon or dad winning Wimbledon – makes an ideal personalised birthday card or framed photo gift. Or just do it for fun.

PROJECT TOOLS: Photoshop Elements ● Photo of an astronaut (see 'Space shots' box, page 63)
SEE ALSO: Image cutouts and photomontage, page 32 ● Make the most of layers and styles, page 26

Open both photos

1 Run Photoshop Elements and click **Edit**. Click **File** and select **Open**. In the **Open** dialogue box, choose the downloaded image file of the NASA astronaut photo (see 'Space shots' opposite), then click **Open**. You also need the picture from which you're going to borrow a face. Go to **Open** on the **File** menu (or press **Ctrl+O**) to show the **Open** dialogue box again; this time choose your portrait photo and open it in the same way.

● Space shots

NASA, the US space agency, has a public collection of photos dating from the early days of the space programme up to the present day. Most are downloadable free of charge without any copyright restrictions. Go to www.nasa.gov/multimedia/imagegallery and use the listings and search options to find what you want. The photo used in this workshop is available at http://grin.hq.nasa.gov/IMAGES/SMALL/GPN-2001-000013.jpg.

● Perfect lighting

Choose your photos carefully when you decide to do a project like the one on these pages. When downloading your space photo, it's important to pick a shot where the astronaut's face is in darkness, so you don't need to remove it before adding your own. Make sure your victim is seen from roughly the same angle as the astronaut. If they're facing in opposite directions, flip one of them over: go to the **Image** menu and choose **Rotate**, then **Flip Horizontal**.

Arrange the images side by side

2 Like other Windows programs, Photoshop Elements lets you see several pieces of work at once in overlapping windows, or choose **Maximise** mode to see only the one you're working on. You can turn **Maximise** mode on and off in the **Images** section of the **Window** menu. Make sure it's off and arrange your windows so the portrait photo is in front with some of the space photo visible behind.

Choose a feathered selection tool

3 Click the **Marquee** icon, fifth from the top in the toolbox on the left of the screen, and hold down the mouse button to access a fly-out menu of options. From this, choose **Elliptical Marquee Tool**, the oval icon. This is the tool that you'll use to cut out the face. To make the cutout fade off around the edges, increase the **Feather** setting in the **Options** bar at the top to **36**.

Create your selection

4 Click at the top left of the face in the photo, hold down the mouse button and drag to draw an oval. Make it fit around the face. During this process you can shift the oval's position if needed by pressing the **Space Bar**, then resume resizing by releasing the **Space Bar**. When it's correctly sized and positioned, release the mouse button. The oval becomes a selection, shown by a flashing outline.

○ Without a trace

To combine photos seamlessly, you need to match their grain as well as colours and lighting. Having transferred a face from your own photo into an archive picture, as in this project, zoom in to **200%** magnification. Do this by holding the **Ctrl** key and pressing the plus (+) key until the title bar above the image shows **200%**. Compare the copied face to the area around it and you may see that your own photo has a smooth texture while the other picture is grainy. With the face layer selected in the **Layers** palette, go to **Filter, Noise, Add Noise**. In the **Add Noise** dialogue box, set **Amount** to **3%**, **Distribution** to **Gaussian**, and tick **Monochromatic**. Click **OK**. The face becomes grainy, but the grain itself is too sharp. Go to the **Filter** menu and choose **Blur, Blur**. If necessary, you can undo (press **Ctrl+Z**) and change the amount of grain.

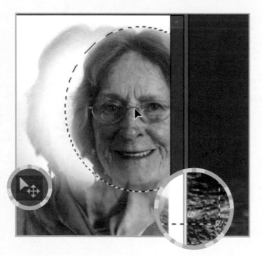

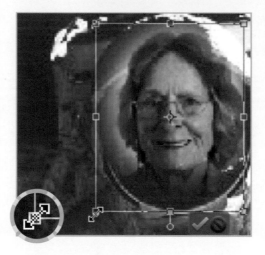

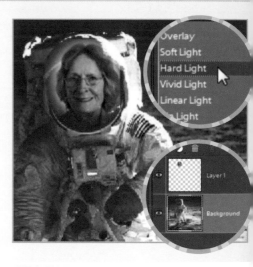

Move the face over

5 Activate the **Move Tool** by clicking the first icon in the toolbox on the left. A 'bounding box' appears around your selection. If you don't see one, tick **Show Bounding Box** in the **Options** bar at the top. Click within the box, hold down the mouse button and drag to the space photo. The face will stop at the edge of the window, but carry on and drop it onto the space photo by releasing the mouse button.

Resize the face to fit

6 The face may appear too big. Click on any of the corner handles of the bounding box and drag it to make the face larger or smaller. Hold the **Shift** key down while you do this to prevent the face changing shape. To move the face, click and drag within the bounding box. Position the face in the helmet. Look at the arms to help you judge where the face should be. Click the green tick (image sharpens) to finish.

Change the blending mode

7 In the **Layers** palette at the bottom right, you'll see that the face is in **Layer 1**, while the **Background** layer contains the space photo. If you don't see the **Layers** palette, open it by choosing **Layers** from the **Window** menu. **Layer 1**'s **Blending mode**, at the top left of the palette, is **Normal**. Click this to pop up a menu and change it to **Hard Light**. Now the space photo partially shows through the face.

● Shadows help trickery

Cutting out a face and putting it into a space helmet is fairly easy because you don't need the edges of the cutout to be exact: they can just fade off into the darkness. It's more complicated to cut out a face and place it on someone else's body in an everyday scene. When planning your image-editing projects be aware that anything on a plain background or in shadow is easier to fake.

● Finishing tweaks

If you're not quite convinced by the results of your photo fakery, try a few tweaks. In the **Layers** palette, the layer containing your copied face has an **Opacity** setting as well as a **Blending** mode. Reduce **Opacity** to about **70%** to make the face recede more realistically within the space helmet. If the colour of the face doesn't look quite right, go to **Hue/Saturation**, as in step 8, and move the **Hue** slider slightly.

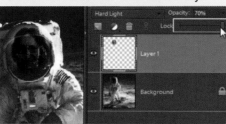

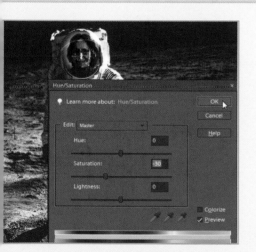

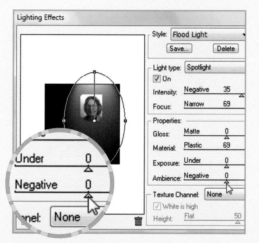

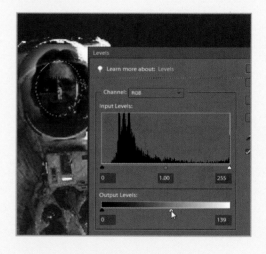

Adjust the appearance of the face

8 The face looks as if it's inside the helmet because the highlights and shadows on the glass appear in front of the face. But the face's colour is intensified, which doesn't match the rest of the photo. To correct this, go to the **Enhance** menu, choose **Adjust Color**, then **Adjust Hue/Saturation** (or press **Ctrl+U**). In the **Hue/Saturation** dialogue box, drag the **Saturation** slider to -30. Click **OK**.

Match the lighting

9 The face should have the same stark lighting as the suit. From the **Filter** menu, choose **Render**, then **Lighting Effects**. At the top of the **Lighting Effects** box, click the **Style** menu and choose **Flood Light**. Looking at the preview on the left, move the light if necessary by dragging the centre point of the oval. At the bottom, reduce the **Ambience** to 0, which stops the face getting too bright. Click **OK**.

Reduce excessive highlights

10 Finally, reduce the highlights on the face. These are part of the space photo, so click **Background** in the **Layers** palette to edit it. Using the **Elliptical Marquee Tool** as in step 3, draw around the face. From the **Enhance** menu, choose **Adjust Lighting**, then **Levels** (or press **Ctrl+L**). In the **Levels** dialogue box, drag the white slider under **Output Levels** to the left, darkening the lightest areas. Click **OK**.

Far and wide

Blend a series of snaps into a seamless panoramic landscape

A panorama is a photo with a very wide angle of view. Camera lenses typically have a field of view of around 50 degrees. Panoramic pictures can have a field of view up to 180 or even 360 degrees, so they can include the entire landscape both in front of and behind you. But you don't need a special camera or dedicated software. With the help of Photoshop Elements you can connect several images taken side by side to create a stunning panorama that you can print out and frame.

PROJECT TOOLS: Photoshop Elements ● Digital camera
SEE ALSO: How to shoot great photos, page 16 ● Erase objects from photos, page 42

> ### ● Manual exposure is best
>
> Most point-and-shoot cameras calculate exposure (aperture and shutter speed) automatically for each shot (see 'Understanding camera controls', page 16). In a wide panorama, lighting conditions will vary depending on what part of it you're shooting, which could result in noticeable differences between shots. Photoshop Elements can compensate but, if your camera has a 'manual' mode, set identical shutter speed and apperture for all the shots, which will ensure the same exposure throughout the panorama.

Take photos and transfer to your PC

1 Take a series of photos, overlapping each by around one-third of an image. A tripod isn't necessary, but try to keep the camera level as you turn your body smoothly through 360 degrees. Make several complete rotations to allow for errors or unwanted people or objects coming into view. Transfer the photos to your PC (see the camera's user manual for details of how to do this).

Make a folder for your images

2 In Windows Explorer, create a new folder and name it Panorama. Now copy into it all the panorama photos that you are planning to use for this project. Click the **Start** button and select **Windows Photo Gallery**. In Windows Photo Gallery, click the icon of the newly created folder in the left-hand pane on the screen. This will let you view thumbnails of your photos in the right-hand pane on the screen.

Turn photos the right way up

3 If you took any photos in portrait (with the camera on its side), they will need to be rotated. Click the first portrait thumbnail, scroll to the right and Ctrl-click any others. Right-click the final portrait thumbnail and select **Rotate Clockwise** or **Rotate Counter Clockwise**, depending on which way they need to go. Windows Photo Gallery will take a short while to rotate them.

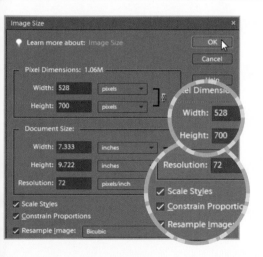

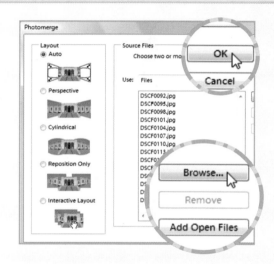

Resize the first photo

4 Run Photoshop Elements and from the **Welcome** screen choose **Edit**. In the **File** menu, choose **Open**. Navigate to and select the first image and click **Open**. In the **Image** menu select **Resize, Image Size**. Make sure the **Constrain Proportions** and **Resample Image** boxes are ticked and, in the **Height** box, type a value of **700 pixels**. The width will adjust accordingly. Click **OK** and save the picture.

Resize the rest

5 In the same way, resize the remaining pictures. Assuming you have six pictures to stitch and that they all overlap by about a third you'll end up with an image that is around 2000x700 pixels. You could make a top-quality 200dpi inkjet print of this measuring 10x3.5in on an A4 sheet of paper (see 'Size matters', page 23). If you have fewer images you can work at a higher resolution.

Start stitching

6 Back in Photoshop Elements, click the **File** menu, select **New** then **Photomerge Panorama**. In the **Photomerge** dialogue box set **Use** to **Folder** and click the **Browse** button, to locate the folder containing the pictures you resized in steps 4 and 5. If there's anything in the list that shouldn't be there, click to highlight it and then on **Remove**. When you're satisfied with the list, ensure **Layout** is set to **Auto** and click **OK**.

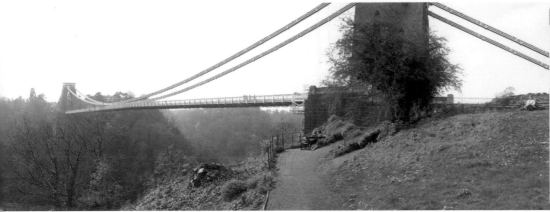

Viewing the merged photos

7 Elements will now combine the images and merge them automatically, overlaying them as accurately as it can. The screen will flicker whilst this takes place and a progress bar displays. When finished a new document, entitled **Untitled_Panorama1**, for example, displays the automatically merged photos. If any of the photos have been placed badly, you can adjust them manually later.

Working with the layers

8 If you look in the **Layers** palette on the right (choose **Layers** from the **Window** drop-down menu if it isn't already visible), you'll notice that each image used in the photomerge process is now displayed as a layer with a linked layer mask showing what part of the image was used in the stitching process. Images that weren't used in the photomerge display as a blank layer and can be deleted.

Filling in the cracks

9 Any areas that haven't stitched together properly can be adjusted manually. Select the **Move Tool** from the toolbox on the left and click a layer in the layers palette to select that part of the panorama. Then, using either the mouse or the arrow keys on the keyboard, nudge the layer slightly so that the seams overlay correctly.

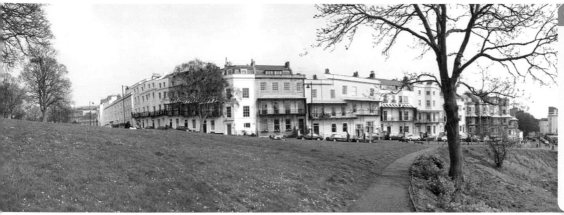

Save and crop the panorama

10 Elements creates your new panorama in a single layer called **Photomerge**. Select **Save** from the **File** menu and save the picture as a **Photoshop (*.PSD)** file. Then select the **Crop Tool** from the toolbox on the left. Click and drag across the panorama to create a rectangle outside of which the ragged edges are trimmed off. Click the green tick icon, bottom right, to confirm the crop.

Make final adjustments

11 Click the **Quick** 'fix' button at the top right. In the **View** dialogue box, choose **Before and After-Vertical**. In the panel, make adjustments by clicking the **Auto** buttons under **Lighting**, **Color** and **Sharpen**, or by moving the individual sliders. See how the adjustments affect your image in the lower, **After**, panel. (See also 'All about colour and resolution', page 22.) Press **Ctrl+S** to save the adjusted image.

Print your panorama in sections

12 From the **File** menu, choose **Print**. In the **Print** dialogue box, untick **Center Image** in the **Position** section and set **Left** to 0. Click **Print** (ignore the warning that clipping will occur). Repeat the process, setting the left position to the width of your paper (–19.7cm for one A4 width), then print that section. Repeat for all the parts, then join the prints to form the complete panorama.

All around the world

Create a lasting visual record of your holiday travels

If you've been on the holiday of a lifetime, it's fun to illustrate your trip with a pictorial map poster. Showing the route of your epic journey together with the stunning photos you snapped along the way will show everyone where you've travelled and what you did while you were there. This project shows you how to find the map, add the route and superimpose your photos to produce a spectacular poster to put on your wall.

PROJECT TOOLS: Photoshop Elements ● Holiday photos
SEE ALSO: Produce a poster, page 56

Copyright on maps

Most maps, including those printed in atlases and ones that you find on the web, are covered by copyright, which means it's illegal to reproduce them without the permission of the copyright owner. Even if you've bought a map, you're not entitled to scan it in and print it out. The copyright owner may agree to you copying the map for personal use, but there could be a fee. Otherwise, use maps that are in the public domain (see the box 'Where to get maps', right).

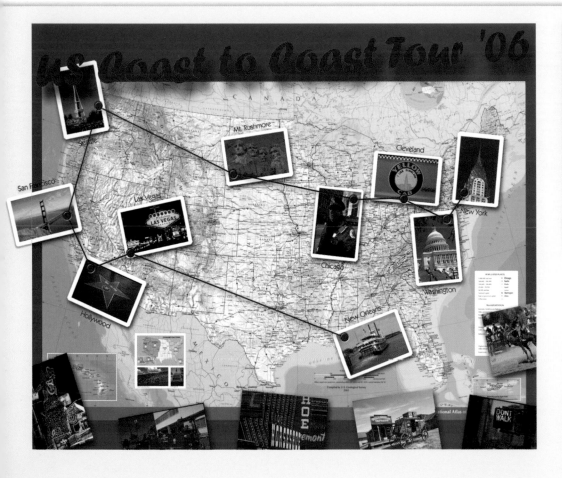

Size your poster

1 Launch Photoshop Elements and click the **Edit** button on the **Welcome** screen. Go to the **File** menu and select **New, Blank File**. In the **New** dialogue box, select **International Paper** from **Preset** and **B3** from the **Size** drop-down menu. This is a good size for a poster and can be printed across four tiled sheets of A4 paper, which are then glued together at the edges. Set **Background Contents** to **White**, **Resolution** to **300 pixels/inch** and click **OK**.

● Where to get maps

The map of the USA used in this project is available free from the University of Texas Libraries website at www.lib.utexas.edu/maps. The site also has maps of other parts of the world, mostly as JPEG or PDF files that are easily opened in Photoshop Elements and other image-editing programs. Another source for free US maps is www.nationalatlas.gov. World maps can be found at http://cia.gov/cia/publications/factbook/docs/refmaps.html. For UK maps, visit the Ordnance Survey's Get-a-map website, at www.ordnancesurvey.co.uk/oswebsite/getamap.

Find and place the map

2 The poster will be landscape format, so select **Rotate** from the **Image** menu, then choose either **90° Left** or **90° Right** from the sub-menu. Download a map to use (see 'Where to get maps', above). Now select **Place** from the **File** menu to add the map background. In the **Place** dialogue box, locate the downloaded map file and click the **Place** button. When you see the **Place PDF** dialogue box, click **OK**.

Size the map

3 You may have to resize the map to fill the page. Holding down the **Shift** key, drag a corner handle to resize the map proportionately until it fills the central area, leaving a wide border all around, then press **Return** to apply the new size. Turn on the rulers and grid from the **View** menu and use them to centre the map. In the **File** menu, choose **Save**, then save your work as a Photoshop (*.PSD) file.

Mark the spot

4 Create location markers to make the places you've visited stand out on the map. Select the **Ellipse Tool** from the toolbox on the left, choose a colour from the **Tool Options** bar and click and drag, holding down the **Shift** key to draw a circle at your first travel destination. To give the marker a 3D appearance, in the **Effects** palette select **Bevels**, then **Simple Pillow Emboss**. Click **Apply** to complete the effect.

⬤ Historic journeys

For smaller-scale expeditions – a country walk, for example – consider using historical maps. Those at www.old-maps.co.uk are a hundred years old or more and, unlike modern maps, you are allowed to use them for non-commercial purposes – to publicise your outing or to record the trip. As well as adding character to your project, old maps offer an insight into how the towns and countryside have changed. Type in a place name, address or map co-ordinates, then click on **Go** to display a map of the area you're interested in. Click **Enlarge Map** for a full-screen map. To save the map, right-click on it and select **Save Picture As** from the pop-up menu.

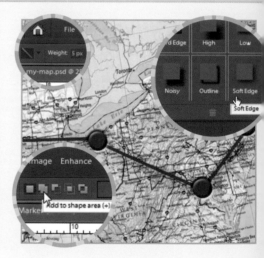

Copying the marker

5 Using the **Zoom Tool**, zoom out to see the marker you just made and the next destination on your itinerary. Re-select the **Ellipse Tool**, then choose the **Shape Selection Tool** (arrow) from the **Options** bar. Hold down the **Alt** key to drag and drop the marker from its original position to the new destination. Pressing the **Alt** key automatically copies the marker, to avoid cutting and pasting it.

Mark all the stops

6 Continue **Alt**+dragging to create new markers positioned on all your itinerary stops. Using the **Shape Selection Tool** to **Alt**+drag the markers keeps them all on one shape layer. If you used the **Move Tool**, a new shape layer would be created for each marker, which would be complicated and unwieldy. Double-click on the name **Shape 1** in the **Layers** palette and rename it Markers.

Join the journey dots

7 Select the **Line Tool** from **Shape Selection** in the toolbox. In the **Options** bar, set **Weight** to **5px** (pixels) and click the **Add to shape area** button. Click and drag to draw a line between your first two markers. In the **Effects** palette, select **Layer styles, Drop Shadows**, then **Soft Edge**. Now connect all the markers. Rename the layer Lines and drag it below the **Markers** layer in the **Layers** palette.

Mapping the route

Budget-priced route-planning programs, such as Autoroute, www.microsoft.com/uk/homepc/autoroute, include printable street-level maps for much of Europe and the USA. As well as helping plan your trip, Autoroute's 'map' view displays the route over a map just like the route markers in this project; while a 'list' view lists towns and cities, roads, directions and distances along the way – a useful accompaniment to your pictorial holiday map.

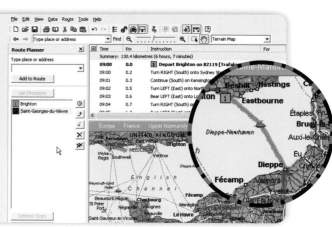

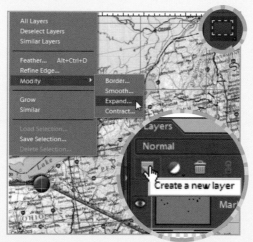

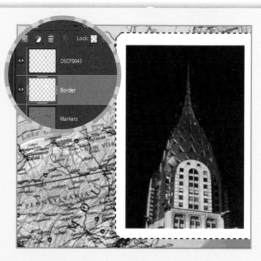

Place your pictures

8 Now it's time to start adding your photos. Select **Place** from the **File** menu, locate the first of your photos in the **Place** dialogue box and click the **Place** button to add it on a new layer. You will probably need to resize each photo you place. Hold down the **Shift** key while dragging a corner handle to maintain its original proportions. Press **Return** or click the green tick icon below the image to confirm.

Create a border

9 To add a white border to the picture, select the **Rectangular Marquee Tool** and set **Mode** to **Normal**. Click and drag around the photo to make a rectangular selection. In the **Select** menu, choose **Modify**, **Expand**, then enter a value of **15** (pixels) and click **OK**. Next, to create a new layer for the border, click the **Create a new layer** button in the **Layers** palette. Rename the layer Border and press **Return**.

Finish off the border

10 Fill the selection with white by first pressing **D** (to set the default foreground and background colours of black and white), then press **Ctrl+Delete** to fill the selection with the background colour. Don't worry if your photo looks as if it's been replaced with a white rectangle – the photo is simply underneath it. Drag the border layer below the photo layer in the **Layers** palette.

● World maps and satellite images

Google Earth is a free program that displays maps and high-resolution aerial and satellite photos of just about any place on Earth. You'll need a broadband connection, as images are 'streamed' to the program in real time over the internet. Map layers you can switch on or off include roads, geographical features, tourist information and even city skylines. Because Google Earth is 3D and animated, moving from place to place on the planet surface is like taking a personal plane trip. You can experience spectacular aerial flythroughs of the world's wonders or even zoom over your home town or city. Some locations – for example, the Grand Canyon and the Himalayas – include 3D views with accurate perspective. Google Earth can be downloaded from http://earth.google.com.

Add a drop shadow

11 Press **Ctrl+D** to turn off the selection. To add a drop shadow to the border, select the border layer, then from the **Effects** palette choose **Drop Shadows** then **Soft Edge**. This makes the photo look as if it's raised up off the surface of the map. To position the route marker and line layers above the photos drag them both to the top of the **Layers** stack.

Think of a caption

12 To add a caption, select the **Type Tool** icon from the toolbox and from the fly-out click **Horizontal Type Tool**. Drag to create a text box and type the location. Choose a sans serif typeface such as **Kabel** that will be legible over the map detail and position it under the photo. **Shift**+click to select the photo, border and type layers in the **Layers** palette and choose **Link Layers** from the **Layers** palette menu.

Give it a tilt

13 Now you can resize, rotate, reposition or transform the photo, border and caption layers as if they were one layer. For an informal look, rotate the photo at a slight angle. Select the photo with the **Move Tool** and position the mouse pointer just outside a corner handle – it changes to a curved double-headed arrow. Click and drag to rotate the photo by a few degrees, then click the tick button.

● Scan your souvenirs

When you get home, don't throw away all the bits and pieces that have accumulated during your trip. Train or bus tickets, airline boarding passes, hotel bills, passport stamps, museum tickets or even local currency can all be scanned in using a flatbed scanner and added to your map. See pages 34 to 35 for more information on scanning.

● Printing issues

It's unlikely your printer is big enough to produce the whole poster in this project on a single sheet, so you'll need to print it out in sections and stick them together (see 'Printing a multi-sheet poster' page 60). Alternatively, take your file on a CD to a copy shop or print specialist, who will print it for you, poster-size, and may offer additional services such as laminating or printing on canvas. See 'Sending out for print', page 91.

Copying a photo

14 Still using the **Move Tool**, Alt+drag the photo/border/caption group to copy it to all of the other locations. Then, for each copied group, right-click its photo layer in the **Layers** palette and choose **Delete Layer** from the pop-up menu. Place a new photo (as in step 8), resizing and rotating to fit the frame (as in steps 8 and 14). Click the caption layer in the **Layers** palette and type the new location.

Add a main title

15 Use the **Type Tool** to create a large text box above the map. The text will need to be quite big – around **100pt** – to make an impact. Use the same colour as the route line or a strong bright colour from the map for the title text. For even greater impact, rotate the text using the **Move Tool** and add a drop shadow style from the **Effects** palette (see step 11). Click **Apply** to finish.

Organise your photos

16 To avoid your map becoming cluttered, use only one photo per destination, adding a selection of other photos in the border area. Place, resize and position them as you did previously, adding a drop shadow if you want. Finally, to add a background colour, select **Background** in the **Layers** palette, and **Fill Layer** from the **Edit** menu. In the **Color Picker** dialogue box select a colour. Click **OK**.

Say it with style

Create your own greetings card for that personal touch

There are ready-made cards for just about all occasions. But one you've designed will be more appreciated than any shop-bought card, and save you money. You can use family photos, children's artwork or pictures chosen specially for the event you're celebrating, then add your own verse to complete the task. In this project you'll make a simple card in Microsoft Word, using images captured and manipulated in Photoshop Elements.

PROJECT TOOLS: Microsoft Word ● Photos ● Colour printer
SEE ALSO: Produce a poster, page 56

Cards the easiest way

Many free cards templates are available for use with Word. Choose **New** from the **Office** button. In the **New Document** dialogue box, you can find templates already installed on your PC, plus more online. Type a word into the **Search Microsoft Office Online for a template** box, or select a category under **Microsoft Office Online**, to browse online for suitable designs.

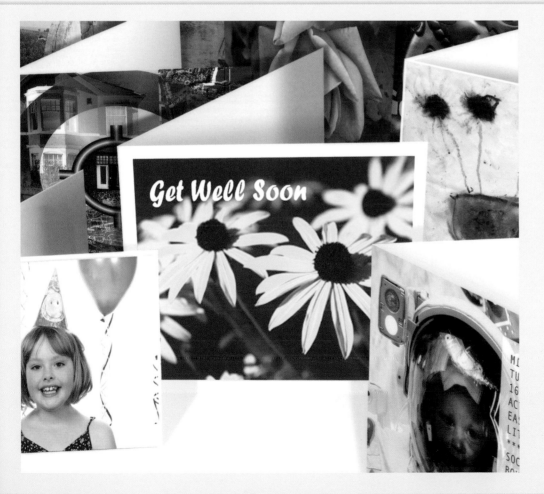

Choose the page size

1 Run Microsoft Word, which opens with a blank document. Click the **Page Layout** tab, then click the **Page Setup** dialogue box launcher. In the **Paper** tab, set **Paper Size** to A4. In the **Margins** tab, set all the margins to **1.3cm** (**0.5in**) and **Gutter** to **0**. Then set **Orientation** to the opposite of the card format you would like – **Portrait** for a wide card folded at the top, or **Landscape** for a tall one folded at the left.

Children's artwork

Children will enjoy helping to design their own cards and party invitations. It's more fun than sending bought cards or ones supplied by party venues. If you have a flatbed scanner, import your child's artwork from a painting or collage and use it on the front of a card, adding text inside using your PC. Or make the whole card by hand, complete with message, and scan it ready for printing.

Professional printing

If you have no printer, high-street printing services will give good results. Using Photoshop Elements, design a card for printing on one side of a sheet of paper 9x7in, with the main image on one half and your message on the other, to be folded down the middle. Save the artwork as a JPEG image then copy the image file as many times as you need cards printed. The high-street printer will treat these as if they were prints from your digital camera.

Set two pages to a sheet

2 In the **Pages** section set **Multiple pages** to **2 pages per sheet**. and click **OK**. The first page of your blank document appears. Click the **View** tab and choose **Print Layout** from the **Document Views** group, to see your page as it will appear when printed. With the **View** tab still selected, click **Zoom** from the **Zoom** group. In the **Zoom** dialogue box click **Whole Page** and then **OK**.

Choose a picture

3 Click the **Insert** tab and then **Picture** from the **Illustrations** group. In the **Insert Picture** dialogue box, navigate to the image file you want to use and click to highlight it. At the bottom right, ensure the button to the left of **Cancel** is labelled **Insert**; if not, click the triangle next to it and choose **Insert** from the menu that pops up. Click this button to import the picture into Word.

Size the picture to fit

4 Your picture is fixed at the top left of the page. The margins you set up in step 1 should be visible as dotted lines. If not, go to the **Office** button and click the **Word Options** button. Now click **Advanced** in the left pane and add a tick to **Show text boundaries** and click **OK**. Click and drag the square handle at the bottom right corner of the picture to enlarge it until it hits the right and bottom margins.

● Paper weight and thickness

Paper, an important part of your design, is classified by weight. A typical greetings card is around 200 grammes per square metre (gsm). Alternatively, the thickness may be quoted in microns (thousandths of a millimetre). Your printer's manual should say what thicknesses of card are recommended for your printer. You can buy greetings card paper pre-creased to fold into a half-page card. If you have a laser printer you must only use paper suggested by the manufacturer, but with an inkjet printer you can try almost any kind. Avoid very thin or soft papers that may disintegrate, or anything with applied effects, such as sparkles, that might come off inside the printer and cause damage.

● Choosing the right type

You can include any wording that you want inside your card, from a short message to a poem. But make sure that the size and font that you select complement the occasion of the card. Try to choose clear and easy-to-read fonts like Palatino or Times New Roman and avoid heavy and over elaborate ones like Old English Text and Palace Script.

Happy Birthday

Happy Birthday

𝔥𝔞𝔭𝔭𝔶 𝔅𝔦𝔯𝔱𝔥𝔡𝔞𝔶

Happy Birthday

Troubleshoot picture sizing

5 When a picture goes over the bottom margin it's trimmed automatically. If it goes over the right margin, click the **Crop** icon in the **Size** group of the **Picture Tools** contextual toolbar, and drag a side handle to trim it. If the handle is off the edge of the page, or if you make a mistake when sizing, right-click the picture and select **Size** from the pop-up menu. In the **Size** dialogue box click **Reset.**

Add more pages to your document

6 Once you're happy with the picture, press the left cursor arrow key, then press **Return**. A new blank page appears before the one containing your picture. Now press the right cursor arrow key, and **Return** again. A third page appears after the picture. Click the **Insert** tab and choose **Page Break** from the **Pages** group. A fourth page is added at the end. Click the **View** tab then click **Thumbnails** from the **Show/Hide** group.

Write a message inside the card

7 With the **Home** tab selected go to the **Font** group and choose a font suitable to the mood of your card. Here it's **Palatino Linotype** with pseudo italic added. Set the size to **36pt**, and click the second of the four alignment buttons on the right, for centred text. Press **Return** a few times so the text cursor is halfway down the card, then type your message. Don't include 'To' and 'From' lines – write them in by hand.

⬤ Print settings for Word

If documents with images print poorly, check your print options. From the **Office** button, choose **Word Options**. In the **Word Options** dialogue box click **Display** on the left and under **Printing options** on the right tick **Background colours and images**. Click **Advanced** on the left, under **Print** on the right untick **Use draft quality** and **Print XML tags**, click **OK**. Also, in the **Print** dialogue box check the printer's settings by clicking **Properties**.

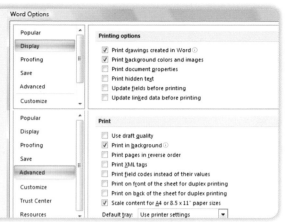

⬤ Choosing envelopes

You'll need to buy envelopes to fit the cards you make. The international A series of paper sizes matches the C series of envelopes. A half-page card printed on A4 paper, folded to A5 size, will fit a C5 envelope. A quarter-page card, folded twice, will fit a C6 envelope.

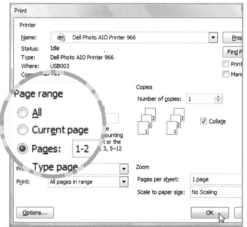

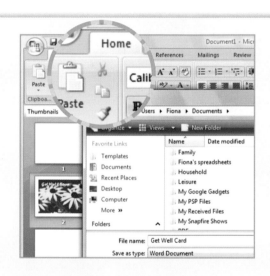

Add a title to the front

8 Now select page **2** in the Thumbnails view. Click the **Insert** tab then **Text Box** from the **Text** group. Select **Draw Text Box** from the bottom of the drop-down menu. The mouse poiner turns into a cross-hair. Click and drag to draw a box for your title. Type in your text, highlight it and move your mouse pointer up to reveal the contextual formatting toolbar. Select a font, size and colour, here Forte, 48pt and White.

Choose printer settings

9 Print your card on greetings card paper or thick photo paper (see box, page 78). Word won't correctly preview a document with multiple pages per sheet, so select **Print** from the **Office** button (or press **Ctrl+P**). Choose your printer at the top, and click **Properties** to adjust its settings. Click **OK**. Under **Page range**, next to **Pages**, type 1-2. Click **OK** to print the first sheet, with the picture at the bottom.

Print on both sides of the paper

10 Feed this printed sheet back into the printer, turning it around so that the blank side is uppermost with the printed picture edge fed into the printer first. (This is the correct way up for most inkjet printers.) Reselect **Print** from the **Office** button and set **Pages** to 3-4. Click **OK**. Fold your card in half with the message inside. Click the **Office** button and then **Save** and choose where to save your card.

Wrap it up

Make a gift special with personalised wrapping paper

Design your own wrapping paper using any kind of artwork – scanned photos or objects, pictures from a clip-art collection, graphics drawn using your software's built-in shape creating tools, or text written in a dynamic font. Here's a way to turn a collage of photos into a seamless repeating pattern which can be printed as many times as you want. It will give you enough wrapping paper for even the largest of presents.

PROJECT TOOLS: Photoshop Elements ● Photos
SEE ALSO: Produce a poster, page 56 ● Make your own greeting cards, page 76

● Instant patterns

You can fill a page with texture or repeating patterns in Photoshop Elements, to create quick and easy wrapping paper. Open a blank canvas (**Ctrl+N**), choose **International Paper** from the **Preset** drop-down menu, and A4 from **Size**. Set **Resolution** to **100 pixels/inch** then click **OK**. From the **Edit** menu, choose **Fill Layer**. In the dialogue box, under **Contents, Use** choose **Pattern**. In the **Custom Pattern** drop-down menu select a pattern then click **OK**.

Open some photos

1 Run Photoshop Elements, and from the **Welcome** screen click **Edit**. From the **File** menu click **New, Blank File**. In the **New** dialogue box, choose **International Paper** from the **Preset** menu then A4 from **Size**. Set **Resolution** to 300, **Color Mode** to **RGB Color** and **Background Contents** to **White**. Click **OK**. Choose **Open** from the **File** menu. Navigate to the folder containing the photos to open. **Ctrl**+click each photo to select several at once, then click **Open**.

● Inspired by nature

Close-up photos of tree bark, grass, leaves or flowers make striking designs. Take your digital camera outdoors to look for subject matter. Point the camera skywards and photograph cloud formations. Copy and repeat the texture, as in steps 11 and 12. The abstract texture will conceal any rough edges. Alternatively, tile (see box, page 83) different textures for a patchwork effect.

● Enhancing old photos

To commemorate a major event in someone's life, it's great to combine recent photos with older ones from the family album, as in this project. Applying a tint to all the pictures (step 13) will help to make them look consistent, but if some of your photos are faded or damaged, you may wish to improve them before adding them to your gift wrap. It is easy to do this using the tools provided in Photoshop Elements.

Set a crop size

2 Crop each photo to a consistent size for use on your gift wrap. Press **C** for the **Crop Tool**. In the **Options** bar, set **Width** and **Height** according to the number of photos you're using. For example, if you have six photos and you're working on A4, each picture, allowing for some overlap when you arrange them, must be more than a sixth A4 size – a quarter (15x10cm), for instance.

Crop your photos

3 In the **Options** bar, set **Resolution** to **300 pixels/inch**, matching your blank canvas. Click and drag on your first photo to draw a crop box. Adjust it to contain the part of the photo you want. Double-click to crop the photo to this area. Crop the next photo in the same way. Differently sized photos may need the **Width** and **Height** values swapped – do this by clicking the two-way arrow symbol between them.

Add the photos to your canvas

4 Press **V** to activate the **Move Tool**. From the **Window** menu, choose the name of your blank canvas to bring its window to the front. Then choose the window containing each photo in turn (do this from the **Window** menu if you can't see the window itself). Click the photo and, holding down the mouse button, drag it onto the blank canvas. Don't worry about size or position yet.

● Choosing paper

Gift wrap is usually quite thin, because thick paper would be difficult to wrap around awkwardly shaped objects. Choose the lightest paper that's compatible with your printer. The printer manufacturer may not have an own-brand lightweight paper, but the printer's manual will list the minimum thickness that it can use. You can then buy paper of that thickness from a stationery supplier.

Plan your photo collage

5 When all the photos are on the canvas, move them around into a rough arrangement. Think about which parts of each photo need to be seen in the finished design, such as faces or costumes, and which can overlap parts of other pictures. Don't resize or rotate the photos at this stage, just plan the arrangement in your head. Repeatedly resizing or rotating will degrade picture quality.

Make an overlapping arrangement

6 Using the **Move Tool**, resize and rotate each picture to fit. In the **Options** bar, make sure **Auto Select Layer** and **Show Bounding Box** are ticked. Click any photo on the canvas to show its bounding box. To prevent the photo changing shape, hold **Shift** while resizing. To rotate, move the mouse pointer slightly away from the handle so it shows a turning arrow symbol, then click and drag.

Finish off your collage

7 After moving or resizing, press **Return** (or double-click) to apply the changes. To alter the way pictures overlap, press **Ctrl+]** to bring a picture forward (on top of others) or **Ctrl+[** to send it back (underneath). When finished, your canvas should be mostly filled, with no gaps between pictures. But keep all the pictures away from the edges, leaving a clear border around all four sides.

● Check your pattern matches

Repeating a pattern by placing copies next to each other, as you'll do with your finished printed sheets, is known as 'tiling'. If, after completing step 12 of this project, you're not convinced that you have a seamless repeating pattern, use the **Offset** filter again to check your tiling. No matter what amounts you enter for the **Horizontal** and **Vertical** offsets, you shouldn't see any discontinuity in the image. This proves it will tile correctly.

● Working with offsets

The **Offset** filter (see step 10, below) is useful for repeating patterns because it moves the edges of your artwork into the middle, where you can fill any gaps. The exact offset amount doesn't matter as long the problem areas (here, the blank white parts) are well away from the edges of the canvas. The amount of offset also governs which parts of the underlying photos show through. If you're not happy with the appearance after step 12, undo (press **Ctrl+Z**), go back to **Filter**, **Other**, **Offset** and try a slightly different number of pixels.

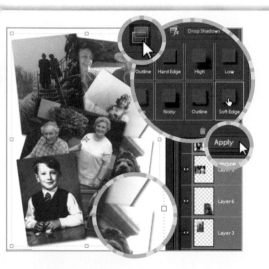

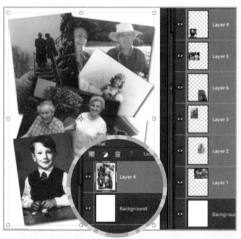

Add soft shadows

8 Shadows give the impression of scattered photo prints. In the **Layers** palette (choose **Layers** from the **Window** menu if you can't see it), click the top layer, containing a photo, then hold **Shift** and click the lowest layer above **Background** so that all your photos are selected. In the **Effects** palette, click the **Layer Styles** icon and choose **Drop Shadows** from the drop-down menu, then pick **Soft Edge** and click **Apply**.

Merge your layers

9 Give your collage a final look over – check that there are no gaps between pictures, or any pictures or shadows going off the edges of the canvas. When you're happy with it, make sure all your picture layers, but not the **Background**, are selected in the **Layers** palette (see previous step), then press **Ctrl+E** to merge all the selected layers. You now have just the **Background** layer and the collage layer.

Duplicate and position the collage

10 Right-click the collage layer (here it's **Layer 4**; yours may have a different name) and choose **Duplicate Layer** from the menu that appears. Click **OK** in the next box to make a copy of your collage, with 'copy' added to its layer name. Now go to the **Filter** menu and choose **Other**, then **Offset**. Enter 1500 into both boxes, and under **Undefined Areas** choose **Wrap Around**. Click **OK**.

● Printing your gift wrap

Choose **Print** from the **File** menu (or press **Ctrl+P**). Click **Page Setup**, choose the paper size that matches your printer and click **OK** to return to the **Print Preview** dialogue box.

When you click **Print**, you may be warned that the image is larger than the paper. This is because many printers can't print a full sheet, right to the edges. Even those that do offer 'borderless' printing often don't recommend it with non-glossy paper. Tick **Scale to Fit Media** to reduce your artwork so that nothing gets missed off. Click **OK** to print, then trim the white borders off the printed sheet with scissors or a craft knife.

Because you've created your photo background as a repeating pattern (see steps 10 to 12 of this project), you may stick multiple sheets together to make a larger piece of gift wrap. The edges will match up seamlessly. Place the sheets next to each other, face down, then apply sticky tape along the join.

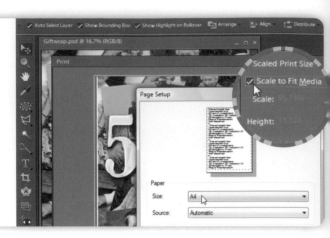

Repeat the patterns

11 The copy of your collage appears a few inches across and down. The parts that are moved off the edge come back on the opposite side. So you're still seeing the whole collage, but the gaps that were at the edges of the canvas are now in the middle. Underneath, the original copy of the collage shows through, filling the gaps. This is the secret of creating a seamless repeating pattern.

Merge and duplicate the layers

12 There will still be four unfilled areas; these were the sides of the original canvas. To fill them, press **Ctrl+E** to merge the two collage layers into one, then duplicate this as in step 10. Again, go to **Filter**, **Other**, **Offset**. Enter a different value into both boxes — say, half the previous amount (750). Click **OK**. You should now have a completely filled canvas. Press **Ctrl+E** to merge one last time.

Tint your photos

13 You can leave your photos as they are, but for a more consistent look, similar to commercial gift-wrap designs, tint them all the same colour. Open the **Hue/Saturation** dialogue box (**Ctrl+U**). Tick **Colorize** to remove any existing colour rather than adjusting it. Then set **Hue** to about 36 for a sepia effect, or whatever colour you prefer. Saturation is automatically set to 25 for a subtle tint. Click **OK**.

● Painting with text

Many gift wrap designs are based on text rather than pictures. Make your own with the **Text** tool in Photoshop Elements, or even using Microsoft Word. It's more difficult to make a repeating pattern with writing, but it's not essential that your gift wrap has a seamless repeat; just stick sheets together without worrying about the pattern matching up.

● Saving your work

Choose **Save** from the **File** menu (or press **Ctrl+S**) to save your artwork as a **Photoshop (*.PSD)** file. You'll then be able to hide or delete the layers containing your message and reuse the photo collage in future projects. If you want to send the artwork to someone else, use **Save As** to resave the file in JPEG format, choosing a high-quality setting (**9** or **10**), or a lower quality (**3** or less) to reduce the file size for emailing.

Add a message

14 Click and hold the **Text Tool** icon on the toolbox and select **Horizontal Text Tool** from the fly-out options. Type a message for the occasion. For tips on entering and formatting text, see steps 4 and 5, page 110. Add as much or as little text as you like, perhaps a full-length message such as Best Wishes on your Golden Wedding Anniversary, or a brief word or phrase. To finish, click twice on the **Move Tool** icon at the top of the toolbox on the left.

Style your text

15 Drag the handles of the text box to adjust the position and size of the text. In the **Effects** palette on the right of the screen, choose **Wow Chrome** and click **Wow-Chrome Shiny Edge** from the options below. Now convert the text to an image by choosing **Simplify Layer** from the **Layers** menu (right). If necessary, use **Hue/Saturation** as in step 13 to alter the colour of the converted text.

Make the text translucent

16 In the **Layers** palette, change the blending mode from **Normal** to **Hard Light**, to make the text see-through. Repeat the text by holding **Alt** while dragging it to make a copy. Position copies so that the distance between them roughly matches the total of the distances between each copy and the edge, both horizontally and vertically. Finally, save your wrapping paper design (see above).

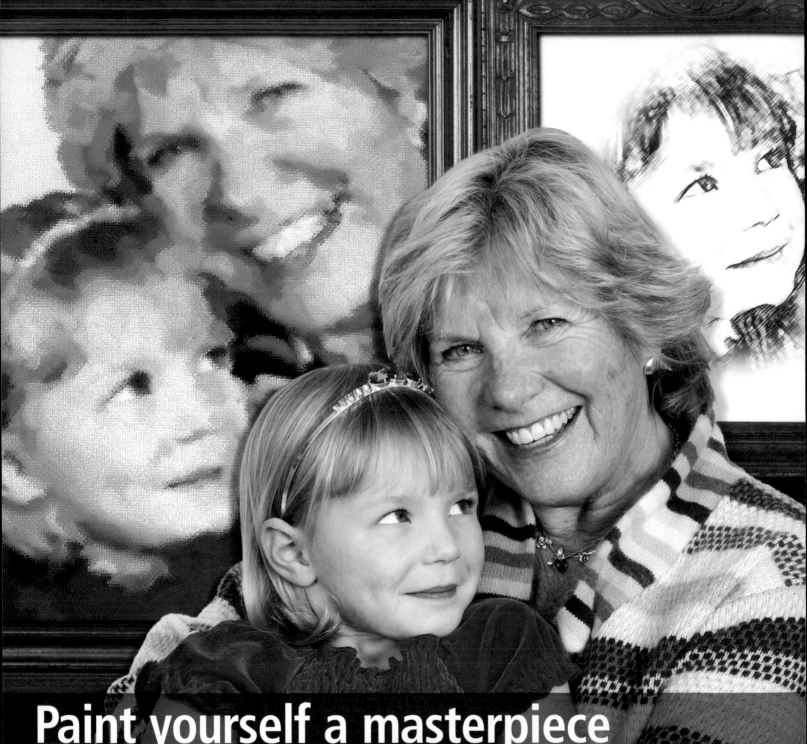

Paint yourself a masterpiece
Learn how to transform a photo into a work of art

Photography is an art in itself, but there's something attractive and intriguing about a painting that's missing from the average family snap. With the help of your PC and image-editing software, you can turn one into the other in minutes. You can start with a photo from your digital camera, or digitise an existing print using a flatbed scanner (see pages 34 to 35 for more on scanning). This project presents an effective method of turning any photo into a painting, which you can then print out and frame as a gift. As with real painting, correct preparation is vital. You'll find out how to prepare your digital canvas and choose the brushes that will give the most convincing results. And just as an artist in oils would apply a final glaze, you'll use some filter effects to put the finishing touches to your work.

PROJECT TOOLS: Adobe Photoshop Elements • Digital or scanned photo • Frame
SEE ALSO: Make your own greetings cards, page 76

Too dark? Too light?

Some effects work best on light images, others on dark ones, and the general tone of your original picture will dictate the results. If an effect comes out looking wrong no matter what settings you make, you may need to adjust the picture's tonal qualities before you apply that effect. An easy method that often works wonders is to use the **Equalize** command, which is under **Adjustments** on the **Image** menu in Photoshop Elements. This automatically evens out the progression from dark to light within the image.

Choose your photo

1 Because you're going to manipulate the photo quite heavily, qualities such as lighting and focus don't have to be perfect. Find a good pose, and make sure the faces are clearly shown. Run Photoshop Elements and click on the **Edit** option. When the program's main screen appears, choose **Open** from the **File** menu or press **Ctrl+O**, and select the image you want to use.

Set a size suitable for printing

2 You should create your painting at the size you want to print it. Press **C** for the **Crop Tool**, or click its icon in the toolbox. In the **Options** bar at the top, enter the **Width** and **Height** you want, followed by in (for inches) or cm. Set the **Resolution** units to **pixels/inch** and enter **300**. You could drop this to 200 to keep file size reasonable, or 100 for large posters (see page 23 for more on resolution).

Crop and scale the image

3 Click at the top left of your photo and drag to draw a crop box. The shape of the box will always match the width to height ratio that you've specified, but you can adjust the overall size to include the portion of the photo you want to base your painting on. When you're happy with the area within the crop box, double-click it or click the green tick icon. The photo is cropped and resized.

Still-life photos make ideal paintings

When working from a photo, a still life of an artistic arrangement of objects offers a similar challenge to a portrait, balancing a painterly look against the preservation of detail. Lighting is all important, so make it dramatic when you take your photo. For an Old Master look, with muted colours, try the **Watercolor** filter, from **Artistic** on the **Filter** menu. Set all the sliders high. Then tint everything brown using the **Sepia** option in **Filter**, **Adjustments**, **Photo Filter**.

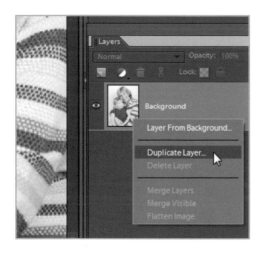

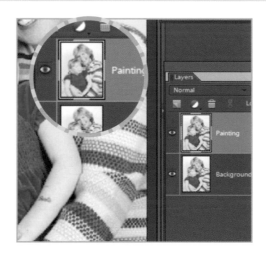

Duplicate your photo

4 After you start painting over your photo, there'll be no simple way to change an area if the picture becomes unrecognisable. So keep an unchanged copy of the photograph in a separate layer behind your artwork. In the **Layers** palette on the right of the screen (choose **Layers** from the **Window** menu if it isn't already visible) you'll see that your image has a single layer called **Background**.

Arrange your layers

5 Right-click this layer name and choose **Duplicate Layer** from the menu that appears. In the dialogue box, name the new layer Painting and click **OK**. The **Painting** layer is now listed above the **Background** layer, and it's this layer that you'll be working on in the main document window. You won't see any change because it's identical. That's all you need do for now; you'll see the benefit later.

Zoom in

6 Before starting to paint, zoom in to a key area of the picture, such as the face. In Elements, you can press Z, or click the magnifying glass icon in the toolbox, to activate the **Zoom Tool**. Then click anywhere within the canvas to zoom in, or hold **Alt** while clicking to zoom out. Alternatively, hold **Ctrl** and press the **plus** or **minus** key: this resizes the window while zooming. Aim to work at **50%** or **100%**.

Make an impression with landscapes

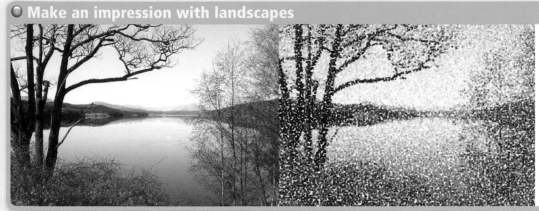

A good landscape photo lets you take more risks with paint effects because you only need a general impression of the scene. The detail can be compromised without making the picture unrecognisable. For example, try the **Pointillize** filter, found under **Pixelate** on the **Filter** menu. This mimics the pointillist technique of Georges Seurat, a French Post-Impressionist painter, breaking up the image into loosely placed dots. Use the largest dot or cell size you can.

Select the Impressionist Brush

7 The **Impressionist Brush** interacts with the colours that are found in your photo. To access it, click and hold the **Brush** icon in the toolbox on the left of the screen. Then choose **Impressionist Brush** from the fly-out options that appear. From the **Options** bar, choose the style and size of the brush as well as the blending mode and opacity, which govern its effect on the image (see page 26).

Choose a brush tip

8 Click the arrow next to the brush sample in the **Options** bar to pop up a menu of brush tips. (You can hover the pointer over a brush tip to pop up its name.) Use the drop-down menu at the top of this to switch from **Default Brushes** to the various sets available. For paint effects, try **Wet Media Brushes**. From about two-thirds of the way down this menu, pick **Brush with Thick Flow Medium Tip**.

Adjust the brush size

9 This is a hard-edged brush, which is good for oil painting with distinct brushstrokes. Softer, more blurry tips suit watercolour effects. When you choose a brush tip, the mouse pointer shows its outline, giving you an idea of size. Check this on your photo: it should be roughly as wide as the smallest feature you need to paint, such as the pupil of an eye. Adjust the brush **Size** setting, if necessary.

Digital art materials

Painting programs that mimic real art materials are known as natural media software. Two examples are Corel Painter X, www.corel.com/painter, a professional-standard application that offers realistic tools – including wet painting – and a more basic version called Painter Essentials. If you prefer instant results, try PhotoArtist 2, by visiting www.benvista.com/photoartist. Digital painting is even easier to do with a graphics tablet, available in various sizes, which gives you a pen rather than a mouse (see page 31).

Set more options

10 The brush is also controlled by the **More Options** menu, the last button in the **Options** bar. **Style** governs the way brush strokes are applied, from **Short** to **Long** and from **Tight** (staying close to your cursor) to **Loose** (spreading out). Try **Loose Medium** first. The **Area** setting can be increased if you want to paint more strokes at once. Leave **Tolerance** at zero.

Start painting

11 Click on the face and hold down the mouse button while you drag to paint. The **Impressionist Brush** picks up colour from the photo and paints with it. Notice how the area around the cursor continues to change rapidly as you hold the button down. Begin with brief dabs, moving a short distance before releasing the button to stop. When you're confident, continue over larger areas.

Assess your work

12 If the face looks too detailed, undo by pressing **Ctrl+Z** and try a larger brush **Size**. If it's unrecognisable, try smaller. Don't preserve details such as eyes, instead paint boldly then restore details using your duplicate layer. To do this, click **Background** in the **Layers** palette, then click and hold the **Stamp Tool** icon in the toolbox and select the **Clone Stamp Tool** from the fly-out options.

● Printing your painting yourself

The easiest way to get your painting onto paper is to use your own colour inkjet printer. **Colour Photo** output mode is usually best, but you can experiment also with modes for colour business documents. Glossy photo paper will give the best print quality, but to mimic a real painting you may prefer to use ordinary matt paper or even try special art papers from craft shops. Inkjets can cope with a wide variety, but watch out for jams.

● Sending out for print

A print shop or digital photo service gives you more printing options. Most photo processors offer enlargements up to around 20x30in (50x75cm). For bigger posters, large-format inkjet printing produces good results. Many services will also print your picture onto canvas, which can then be framed. Alternatively, some print shops use a deeper than usual stretcher (the unseen supporting frame) to make the canvas more three-dimensional, with the image wrapping around the sides. You can hang this unframed for a more modern look.

Recover lost detail

13 In the **Options** bar, tick **Aligned**. Untick **All Layers**. Set brush **Size** similar to before, **Mode** to **Normal**, and **Opacity** to **100%**. Holding the **Alt** key, click on the canvas to set the source for cloning. Leaving the cursor exactly where it is, switch to the **Painting** layer using the key shortcut **Alt+]**. Release the **Alt** key, then click and drag to paint. The original photo reappears where you brush.

Paint detail finely

14 Having restored an area of detail, go back to the **Impressionist Brush** by pressing **B**. Reduce the **Size** setting in the **Options** bar and, in the **More Options** menu, set **Style** to **Tight Short**. Now repaint the area. Note that whenever you need to restore another area, you can switch to the **Clone Tool** and paint straight away. Thanks to the **Aligned** setting, you only have to set the source point once.

Paint the background broadly

15 Moving away from the face, you can paint other areas with larger, looser strokes, as detail isn't so important. For the hair, increase the **Size** setting by at least half and change **Style** to **Loose Long**. Areas such as clothing can be painted with an even larger brush. If patterns, such as stripes, appear broken up, try setting **Mode** to **Color** to preserve light and shade, or **Luminance** to keep colour.

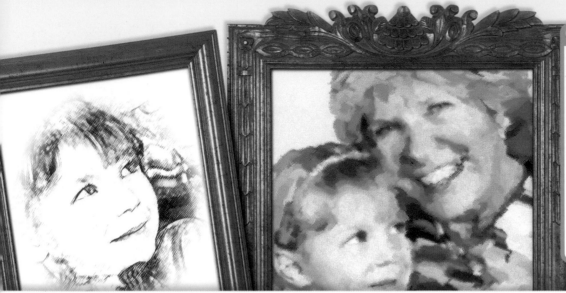

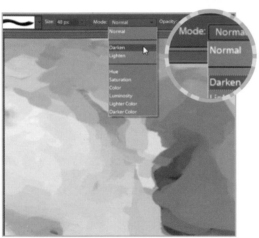

Finish off the brushwork

16 Continue through the rest of the picture. Make sure every part of the photo is covered with brush strokes, not forgetting empty background areas, which still need to have a matching texture. Where necessary, try changing **Mode** to **Darken** or **Lighten** to paint in shadows or highlights that have been evened out by the brushwork. The same trick can be used to repair edges that are overly jagged.

Enhance the paint effect

17 For a final touch of realism, use one of Elements' **Artistic** effects, found on the **Filters** menu. Though it may seem inappropriate for an oil painting, choose **Rough Pastels**. Reduce **Stroke Length** and **Detail** to about **3**, set **Texture** to **Canvas**, and increase **Scaling** so the texture is clearly visible in the preview image at **100%**. Set **Relief** to **20** and **Light** to **Top Right**. Click **OK**.

Complete the painting

18 From the **Image** menu, choose **Rotate, 90° Right**. With the picture now turned sideways, reapply the same **Rough Pastels** filter by pressing **Ctrl+F** to repeat the last filter used. This exaggerates the effect and corrects the impression that all the brush strokes are biased in one direction. Then use **Image, Rotate, 90° Left** to turn the picture back the right way up.

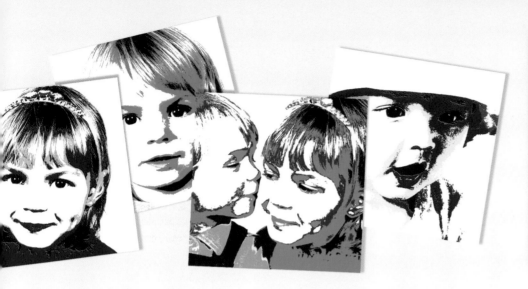

> **● Pop Art effects**
>
> How about doing what Andy Warhol did with his prints of Marilyn Monroe and Elvis Presley and breaking down your photos into vibrant fields of colour? A useful filter for this kind of effect is **Posterize** (**Filter** menu, **Adjustments**), or you can push up brightness and contrast (**Enhance** menu, **Adjust Lighting**, **Brightness/Contrast**). Even better is Photoshop Elements' **Shadows/Highlights** filter, under **Adjust Lighting** on the **Enhance** menu. Set **Midtone Contrast** to maximum, with the other sliders at zero and then repeat.

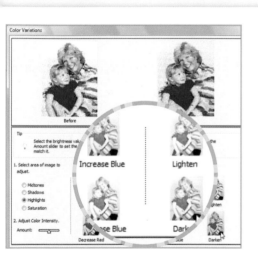

Add a glaze

19 The finishing touch is to alter the picture's colour to resemble more closely a real oil painting. To do this, go to **Adjust Color** on the **Enhance** menu and choose **Color Variations**. In the dialogue box, set the **Amount** slider just above halfway. Select **Highlights**, then click **Increase Green**, **Increase Red**, and **Darken**. Check the preview and click **OK**. Your painting is ready to save, print and frame.

Try sketching

20 Photoshop Elements' **Sketch** filters can turn a photo into a pencil drawing or similar with just a few clicks. Starting with the original photo, crop and scale it as in steps 1 to 3. Prepare it by choosing **Equalize** from **Adjustments** on the **Filter** menu. Go to **Filter**, **Sketch**, and choose an effect – here it's **Charcoal**. Adjust the sliders to give high contrast with shading just visible in the lightest areas.

Create a vignette

21 A vignette is where the picture fades out to form a shape such as an oval. To create this, click and hold the **Marquee Tool** icon in the toolbox and select **Elliptical Marquee Tool** from the fly-out options. Set **Feather** in the **Options** bar to about 50. You can vary this depending on the size of your image. Now click and drag around an area. Choose **Inverse** from the **Select** menu, then press **Delete**. Use the **Crop Tool** to crop off the blanked area.

Happy families

Use your family members as characters in a deck of cards

Card games are even more fun with personalised cards. Here's how to make Happy Families cards featuring your own family. Traditionally, each family in the pack has a different profession or hobby. Take photos of yourselves acting these out or use pictures from your family album, then turn the photos into wacky caricatures. Add text and a background, and your cards are complete.

PROJECT TOOLS: Photoshop Elements ● Family portrait photos
SEE ALSO: Draw a comic strip, page 48 ● Photo filters and special effects, page 28

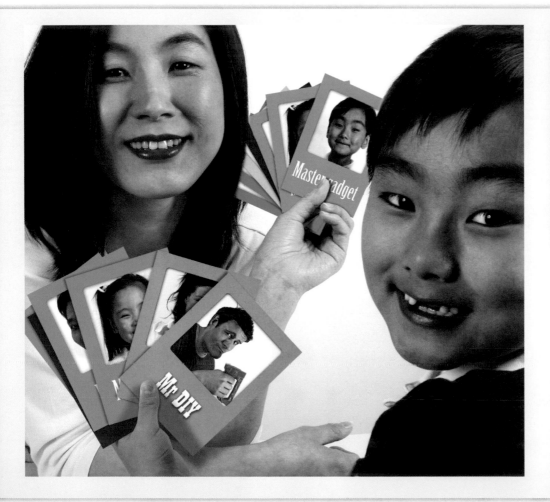

Choose a size for the cards

1 Run Photoshop Elements and from the **Welcome** screen choose **Edit**. Then from the **File** menu choose **New, Blank File**. In the **New** dialogue box, set **Width** to **2.5 inches** (6.35cm) and **Height** to **3.5 inches** (8.9cm), or choose a different size if you prefer (see 'Size and shape' box, page 97). Set **Resolution** to **300 pixels/inch** and **Color Mode** to **RGB Color**. Ignore **Background Contents** for the time being and click **OK**.

Rules of the game

To play Happy Families, shuffle and deal the cards (up to 48, or 12 families) to three or more players. The first player asks an opponent for a specific card, say 'Mr X'; the person asking must hold at least one card of that family. If the opponent has the card, it must be handed over, and the player then asks the same or another opponent for a different card. If that opponent doesn't have the card, it's that player's turn. When all the families are complete the player with the most families is the winner.

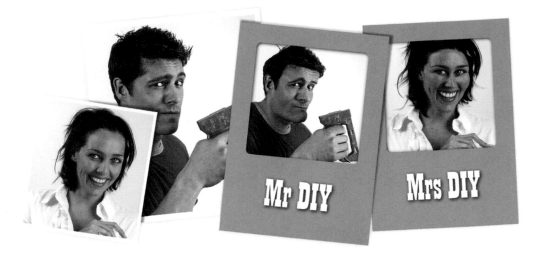

Pick a background colour

2 Go to the **Edit** menu and choose **Fill Layer**. In the **Fill Layer** box, set **Mode** to **Normal** and **Opacity** to **100%**. In the box labelled **Use**, choose **Color**. The **Choose a color** dialogue box appears. Select a colour you like from the spectrum in the middle, then click on the palette on the left to set the exact shade for the cards. Choose something vibrant but not too vivid. Click **OK**, then click **OK** in the **Fill Layer** box.

Make a picture frame

3 Click and hold the **Shape Selection Tool** icon in the toolbox on the left of the screen. From the fly-out options, select the **Rounded Rectangle Tool**. In the **Options** bar, set **Radius** to **0.1in (2.5mm)**, click the arrow next to **Color** and choose **White**. Now click at the top left corner of your canvas making sure you're on the canvas, not the edge of the window. The mouse pointer should show a crosshair.

Adjust your picture frame

4 Pressing **Shift**, click and drag diagonally down and to the right until the shape reaches the right side of the canvas, then release the mouse button. Go to the **Image** menu and choose **Resize**, then **Scale**. To keep the shape centred, highlight the middle square (anchor point) in the small diagram on the left of the **Options** bar. Set both **W** and **H** (width and height) to **75%**. Click the green tick to finish.

Other card games

Use the techniques in this project to make a pack of cards for the game of Snap. You could alter the pairs in **Liquify** to make it harder to spot a match, or use different photos of each person for each pair. If you're really ambitious, design a standard 52-card pack, substituting your friends and family for the picture cards – the king, queen and jack of each suit and, of course, the joker.

Shadow effects

You can make the characters look as if they're sitting behind a window in the card by adding a shadow within the picture frame. In the **Layers** palette, click the text layer. In the **Effects** palette (choose it from the **Window** menu if you can't see it), pick **Layer Styles** (the second icon from the left), then **Drop Shadows**. Under that, select **Low** and click **Apply**. Click the **Shape** layer, switch from **Drop Shadows** to **Inner Shadows**, and pick **Low**, then click **Apply**. Do this on your first card, and the effects will apply to all the rest.

Type in a family member's name

5 With the centre square resized, click and hold the **Text Tool** icon in the toolbox and select **Horizontal Type Tool** from the fly-out options. Choose a font and size from the **Options** bar. The icon labelled 'AA' must be highlighted for **Anti-aliased** (smooth) text. From the three buttons showing horizontal lines, click the middle one to centre the text. Click on your canvas below the shape.

Type the longest title first

6 Happy Families members are traditionally titled Mr, Mrs, Master and Miss. Think of a name for your family and type Master (the longest title) followed by the family name. Highlight the text by dragging over it, then adjust the size in the **Options** bar. As 'Master' is the longest title, you now know that the others will fit. Click the **Move Tool** (top icon in toolbox on the left) twice, then drag the text to position it.

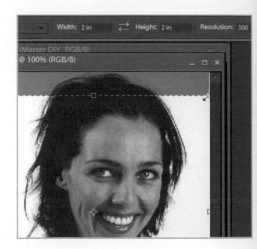

Open a photo to edit

7 If the first card you want to design isn't 'Master', click back on the text with the **Text Tool** and change it, but leave the size the same. Now choose **Open** from the **File** menu and open the photo that you want to edit. Press C for the **Crop Tool**. In the **Options** bar, set **Width** to **2in** – half an inch (1.25cm) less than the width of your card. Set **Height** the same. Set **Resolution** to **300** pixels/inch.

Size and shape

The size of your cards is your choice. Standard playing cards are 2.5x3.5in ('Poker' size, paper format B8) or 2.25x3.5in ('Bridge' size). Happy Families can be played with up to 48 cards: 12 families, each comprising Mr, Mrs, Master and Miss. If you only have time to design one family, then copy them with different names, and change the background colours by repeating **Fill Layer** (see step 2). Or you could use the same set of photos from one family, but process them differently using **Liquify** to create a series of imaginary families.

Why stop at cards?

Card games aren't the only kind you can personalise using image-editing software. You could also make a Snakes and Ladders board. Choose **A4** or **Letter** from the **Preset** menu in the **New** dialogue box (see step 1) to make a full page. Draw the squares using the **Rounded Rectangle Tool** (see steps 3 and 4) and label them using the **Text Tool** (steps 5 and 6). Browse the **Custom Shapes** (see step 15, 'Draw a comic strip', page 53) for animals and other fun symbols you can add.

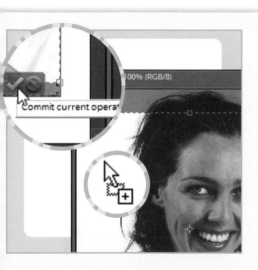

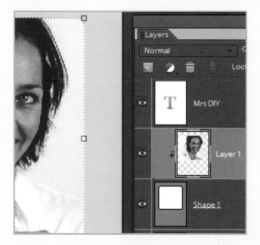

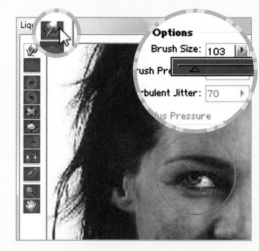

Size the photo to fit

8 Click near the top left of the canvas and drag to draw a crop box. Adjust this by dragging the corner handles to surround the area of the picture you want to use. Double-click or click the green tick icon to finish. Press **V** for the **Move Tool**. Now click on the photo and drag it across onto the window containing your card design. Drop it onto the card, then drag to position it over the shape you made.

Place the photo in the frame

9 In the **Layers** palette, drag the photo's layer one step down, so it's below the text but above the shape. Now press **Ctrl+G**. This groups the selected layer (the photo) with the one below (the shape), meaning that the photo is only visible within the shape. To turn the photo into a caricature, go to the **Filter** menu and choose **Distort**, then **Liquify**. The **Liquify** box appears, showing only the photo (the current layer).

Choose a tool and brush size

10 On the left are the eight distortion tools. Below them is **Reconstruct**, which undoes changes, then **Zoom** and the **Hand Tool** (for moving around the canvas when zoomed in). Using **Zoom**, click the face to enlarge it, then click the top tool icon, **Warp**. Move the mouse over the photo, then adjust the **Brush Size**, on the right, so it's about a third of the width of the face. Set **Brush Pressure** to 50.

● Printing out your cards

From Photoshop Elements click **File**, **Open** and then open the JPEG files of all the cards to print. Click **File**, **Print Multiple Photos**. The **Organizer** module opens and shows the **Print Photos** dialogue box, with thumbnails of your cards on the left. On the right, choose your printer and paper. Click the menu labelled **Select Type of Print** and choose **Individual Prints**, then click the menu **Select Print Size and Options** and choose **Custom**. In the dialogue box that opens, set the same **Width** and **Height** as you used to create your cards. Click **OK**, then untick **One Photo Per Page**, so your cards are arranged automatically on as many pages as necessary. Finally, click **Print**. For best results, print on the thickest glossy card that your printer manufacturer recommends. Cut out your cards with scissors or a craft knife.

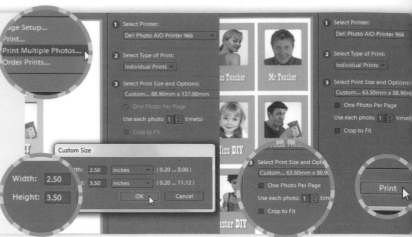

Raise the cheekbones

11 Caricatures generally exaggerate facial features. For results even your subject will appreciate, accentuate the positive and don't make changes too extreme. Here, the mother's smile is crinkling up the eyes, so emphasise this. Click with the circle centred on the right pupil, and drag gently to move the eye slightly inwards. Do the same with the left. Then click each cheekbone in turn and pull it up.

Get a nose job

12 Female noses tend to be smaller than male, so exaggerate this. Choose the fifth icon in the toolbox, **Pucker Tool**. Place the circle over the nose, then click and hold down the mouse button briefly to suck the area into the centre. If you make a mistake at any point, press **Ctrl+Z** to undo, or choose the **Reconstruct Tool**, then click and hold anywhere on the photo to return that area to normal.

Working on teeth and hair

13 The mouth is hardest to alter without looking unnatural. With the **Pucker Tool**, click just above one corner of the mouth and squeeze it slightly, then do the same the other side. This will also flare the nose a little. Switching back to the **Warp Tool**, drag the hair bit by bit down towards the face, making a lower hairline. Use a small **Brush Size** to pull some of the flyaway ends further out.

● Professional printing

For a high-gloss finish, use a high-street or online digital photo service. For example, go to www.kodakgallery.com and click **International Sites** at the bottom and choose **United Kingdom**. Follow the instructions to upload files and order prints.

A good option is to print two cards side by side as a single 6x4in photo and cut it in half. Make your cards 3x4in (step 1). Open one of your finished JPEG files in Photoshop Elements. From the **Image** menu choose **Resize**, then **Canvas Size**. In the dialogue box that opens, set **Width** to **200 percent**, leave **Height** alone and click the middle left **Anchor** position. Click **OK** to make a space. Open another finished card. With the **Move Tool** (press **V**), drag this onto the first and position it in the space. Press **Ctrl+E** to merge them together. Go to **File**, **Save As**, and save in **JPEG** format with a new file name. Repeat to pair your other cards.

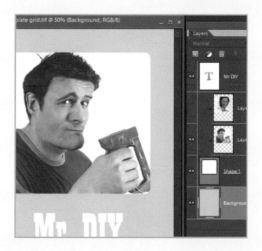

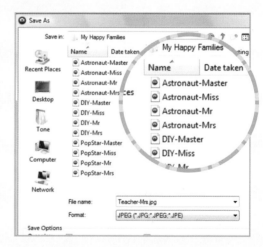

Save the project

14 Finish tweaking, then click **OK**. Choose **Save** from the **File** menu and browse to a folder to save your card in. Enter a file name such as Card Template, and leave **Format** set to **Photoshop (*.PSD)**. Click **Save**. Go back to the **File** menu, choose **Save As** and enter a file name for this particular card. Set **Format** to JPEG. Click **Save**. Set **Quality** to 8, then click **OK** to save a copy of the file for this card.

Design a second card

15 For your next card, repeat steps 7 and 8: alter the text, open another photo, crop it, drag it onto your card and position it on top of the previous photo. In the **Layers** palette, click the eye icon next to the previous photo's layer to make it invisible. Drag the new photo down so it's directly above the shape layer. It groups automatically, fitting within the shape. Use **Liquify** as before to create the caricature.

Complete the family

16 Again, update your Photoshop file using **File**, **Save**, then save a copy of the second card as a new **JPEG** file using **Save As**. Add your third photo in the same way. Create as many cards and families as you wish, ending up with one layered Photoshop file (useful for later editing) and individual **JPEG** files of all the cards. For tips on printing your cards, see boxes on pages 98 and 99.

Face painting by numbers

Improve the way you look with a virtual makeover

Photos can be unflattering – washed-out skin tones, a shiny nose or pimples do little for anyone's confidence. Thankfully, all these can be easily fixed with the help of photo-editing software. In minutes, you could look as flawless as a model or movie star. And you don't have to stop there. If you're curious about how you'd look with a different hairstyle, eye colour or make-up, just photograph the parts you'd like and try them on for size.

PROJECT TOOLS: Photoshop Elements ● Photos
SEE ALSO: Family card game, page 94

Taking the ideal photo

You can do a makeover on any photo, but for best results take one specially. Find a place and time when the light is bright but not too harsh, and make sure your face isn't in shadow. If possible, use a white or plain background. Position the camera so that your face fills most of the frame. Use a tripod or place the camera on something firm; using the self-timer is ideal because nobody will wobble the camera during the shot.

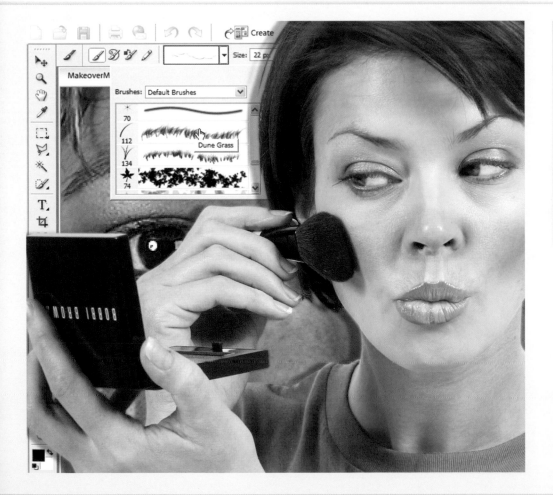

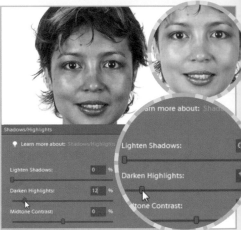

Enhance your skin tone

1 Run Photoshop Elements and from the **Welcome** screen choose **Edit**. Press **Ctrl+O** and in the **Open** dialogue box double-click on your photo. If you look a bit washed out, go to the **Enhance** menu and choose **Adjust Lighting**, and then select **Shadows/Highlights**. Set **Lighten Shadows** to **0** and increase **Darken Highlights** a little. For darker skin, try increasing **Lighten Shadows**. Click **OK**.

A healthy glow

Since the early days of cinema, three tricks have been used to create a 'film star' look: diffuse lighting, soft focus and over-exposure. You can mimic all of these using Photoshop Elements' **Diffuse Glow** function, found under **Distort** on the **Filter** menu. Set **Graininess** to a small amount, such as **2**, then adjust the other sliders – the higher the **Glow Amount** and the lower the **Clear Amount**, the stronger the effect will be.

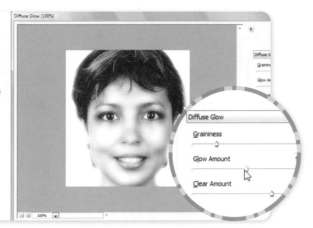

Nobody's perfect

Although this project does a thorough job on its subject, you should be wary of going too far 'improving' a portrait photo. Nobody has a perfect face, and removing a prominent mole or fixing chipped teeth may make someone look odd to those who know that person well. Stick to enhancements such as removing blotches, tidying up hair and whitening eyes, and leave a few flaws intact for the sake of realism.

Prepare the Healing Brush

2 Click and hold the **Healing Brush** icon (sticking plaster) in the toolbox on the left of the screen, and choose **Healing Brush Tool** from the fly-out options. In the **Options** bar at the top, click the icon labelled **Brush**. Set **Hardness** to **0%**, **Spacing** to **25%** and **Roundness** to **100%**. Adjust **Diameter** so the brush is slightly bigger than the spot you want to remove.

Remove spots and blemishes

3 Also in the **Options** bar, set **Mode** to **Normal** and **Source** to **Sampled**, and tick **Aligned**. Hold **Alt** and click somewhere on the photo where the skin tone is the same as around the spot to be removed. This sets a 'source point' (similar to that used with the **Clone Tool**; see page 33). Release the **Alt** key, then click on the spot and drag to cover it. Cover other blemishes, setting a suitable source point each time.

Sharpen your eyes

4 The eyes should be sharp and clear. Click and hold the third icon from the bottom of the toolbox, then choose the **Sharpen Tool**. In the **Options** bar, choose a soft brush (plain with fuzzy edges). Set **Size** to about **40px** and **Strength** to **25%**. Click on an eye and, holding down the mouse button, 'paint' over it to sharpen. Sharpen both eyes, but not too much, avoiding the wrinkles around them.

● Put on your virtual wig

Going thin on top? Open your photo, click and hold the **Marquee Tool** icon in the toolbox and select **Elliptical Marquee Tool**. In the **Options** bar, set **Mode** to **Normal**. Click and drag to draw an oval over the scalp. Press the **Spacebar** while drawing to move the shape. Hold **Alt** and draw an overlapping oval to subtract the face, leaving a crescent shape selected. Choose **Feather** from the **Select** menu and enter **12**, then click **OK**. Copy this area into a new layer by pressing **Ctrl+J**. Press **D** to choose black and white. Go to the **Filter** menu and choose **Render, Fibers** (**1**). Set **Variance 16, Strength 12**. Click **OK**. You now have hair but it's too straight. From the **Filter** menu, choose **Distort, Wave** (**2**). Set **Generators** to **20**, **Wavelength** to **40 Min** and **80 Max**, **Amplitude** to **1 Min** and **4 Max**, and **Scale** to **100% Horiz** and **Vert**. Click **OK**.

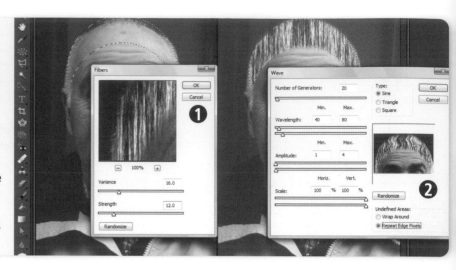

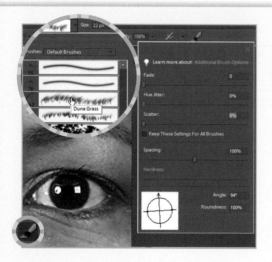

Choose an eyelash brush

5 Pick **Brush Tool** from the toolbox on the left (it shares the icon just above the **Paint Bucket Tool** with the **Pencil Tool** and advanced Brush tools). In the **Options** bar, click the **Brush** preview, scroll down the list and choose **Dune Grass**. Reduce **Size** to **22px**. Click **More Options**. Set **Fade 0**, **Hue Jitter 10%**, **Scatter 0%**, **Spacing 100%**, and **Angle 94°**. Press **Return**, then press **D** to set the painting colour to black.

Paint thicker, longer eyelashes

6 Click near the outer corner of the eye on the left and, holding down the mouse button, paint on some extra lashes. Adjust **Size** and **Angle** if needed; the lashes here should be almost horizontal – use the existing lashes as a guide. Click and paint again to add more. Only add lashes near the edge of the eye. To do the other eye, go to the **Image** menu and choose **Rotate**, then **Flip Horizontal**.

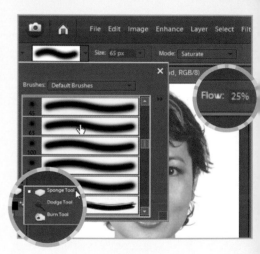

Boost hair highlights

7 The photo is flipped over, and you can brush matching lashes onto the other eye. Then use **Flip Horizontal** again. Now turn your attention to the hair, where you can exaggerate any existing highlights. Click the bottom icon in the toolbox and choose the **Sponge Tool**. In the **Options** bar, set **Mode** to **Saturate** and **Flow** to **25%**. Choose a soft brush and a fairly large **Size**.

How to select by colour

When using **Replace Color** (see step 16), pick the **Selection** option. As you hold **Shift** and click on your photo, all areas matching the colour where you click are added to the selection, shown in white. Adjust the **Fuzziness** to select less or more. If you can't avoid areas getting selected because they're similar in colour, click **Cancel**, then use the **Polygonal Lasso Tool** to draw roughly around the item. Go back to **Replace Color** and try again.

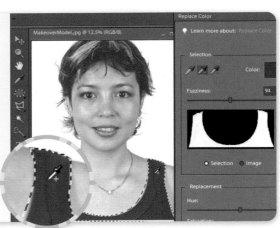

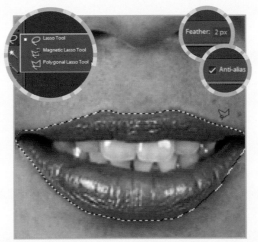

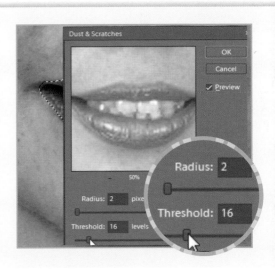

Paint over existing highlights

8 By clicking and dragging, paint over the highlights in the hair to boost their colour. Repaint an area if you want to make it even brighter. Use the **Sponge Tool** to enhance colour elsewhere – for example, to make the subtle eye make-up here more obvious and to make the lipstick more vivid. Change the mode to **Desaturate** to remove colour – for example, to conceal red veins in the eyes.

Create fuller lips

9 Click the **Lasso** icon in the toolbox on the left and, from the fly-out options, choose the **Polygonal Lasso Tool**. Then in the Options bar, set **Feather** to **2px** and tick **Anti-alias**. Click on the corner of the mouth, then release the mouse button and move to draw a straight line. Position this along the outline of the lip and click again. Continue all the way around and finish where you started.

Iron out wrinkles

10 With the mouth selected (shown by a flashing dotted outline), go to the **Filter** menu and choose **Noise**, then **Dust & Scratches**. In the dialogue box, set both sliders to **0**, then increase the **Radius** until the wrinkles disappear from the lips – **2** or **3** should do it. Now increase the **Threshold** to around **16**, so other details return and the mouth appears natural. Click **OK**. Press **Ctrl+D** to cancel the selection.

● How to borrow someone else's hairdo

All you need is a photo of another person and one of you at a similar angle. Open both in Elements (use **Open** from the **File** menu), press **V** for the **Move Tool** and drag the other person's photo onto yours (**1**). In the **Layers** palette (choose **Layers** from the **Window** menu if you can't see it), change blending mode from **Normal** to **Soft Light**, so your face shows through (**2**). Drag the 'bounding box' corners to resize the new face to match (**3**), lining up eyes and mouth. You can enlarge the window by dragging its bottom right corner down and right. Set blending mode back to **Normal**. Click the **Eraser Tool** icon from the toolbox on the left and select the first option for the normal **Eraser Tool**. Click the **Brush** preview and choose a medium-sized, plain, soft-edged brush. Paint inside the hair edges (**4**) to reveal your own face.

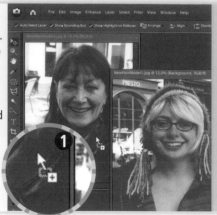
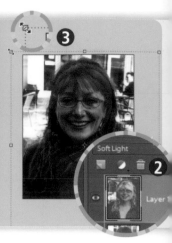

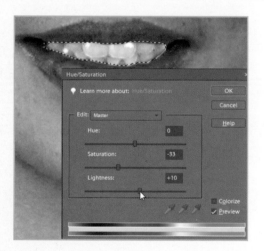

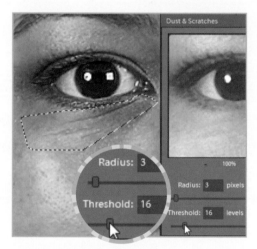

Whitening teeth

11 Using the **Polygonal Lasso Tool** again (see step 9), draw around the teeth. In the **Enhance** menu choose **Adjust Color**, then **Adjust Hue/Saturation** (or press **Ctrl+U**). In the dialogue box, reduce **Saturation** by about a third to a half (**-33** to **-50**) to remove any yellow, and increase **Lightness** a little for extra sparkle. Be careful not to make the teeth too white or they won't look real. Click **OK**.

Remove lines around the eyes

12 With the **Polygonal Lasso Tool** selected, draw around any area of the face affected by lines or wrinkles, such as under the eyes or around the mouth. Choose **Dust & Scratches**, as in step 10, from **Noise** on the **Filter** menu. Move both sliders to the far left, then carefully increase the **Radius** to catch the wrinkles, and do the same with the **Threshold** to keep the skin texture looking natural.

Dealing with shiny skin

13 Press **Ctrl+D** to deselect. Bright highlights can make skin appear shiny. To reduce the shine, press **J** to switch back to the **Healing Brush Tool**, and use it as in step 3 – **Alt**+click to pick up a non-shiny area of skin, then click and drag to paint it over a highlight. If necessary, increase the **Brush Size** in the **Options** bar, but don't try to cover a large area all at once; instead, work inwards from the edges.

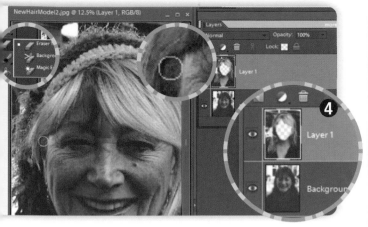

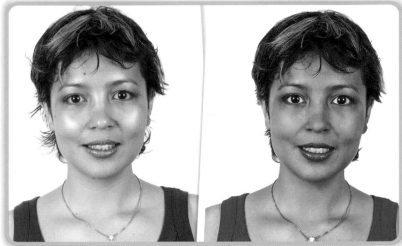

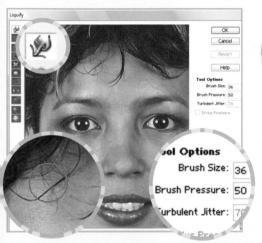

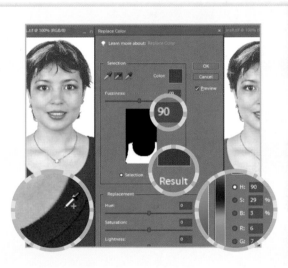

Clean up the forehead

14 There are some stray hairs lying messily across the forehead. You can push these out of the way. From the **Filter** menu choose **Distort**, then **Liquify** (see step 9, page 97). Click the **Warp Tool** icon at the top of the toolbox on the left of the window. Then adjust **Brush Size** on the right so it's around the diameter of a pupil. Click and drag any wayward locks to tease them into shape. Keep your changes small.

Remove flyaway ends

15 Press **L** to switch back to the **Polygonal Lasso Tool**, then draw around the outside of the face, where you want the hair to finish. Take your outline around and over the top to form a helmet shape. With the selection completed, choose **Feather** from the **Select** menu and enter **16**. Click **OK**. Press the **Delete** key to erase the rest of the hair. This only works if your photo is on a white background.

A change of outfit

16 From the **Enhance** menu, choose **Adjust Color**, then **Replace Color**. Move the mouse pointer over the photo (it shows an eyedropper) and, holding **Shift**, click repeatedly on the item you want to change – here it's the person's top. Adjust the **Fuzziness** slider so this area is shown white, with the rest of the photo black. Click the colour swatch labelled **Result** and choose a colour. Click **OK** to apply it.

Fancy dress
Try on a new face with a party mask

Wearing masks is a party tradition with kids and adults alike, whether it's comical masks for a social get-together or scary ones for Halloween. To create a mask, all you need is a digital or scanned photo or drawing of a face. A great twist is to mirror one side of the face to make it symmetrical. Try using animals, famous faces – perhaps found on the internet – or even the faces of your party guests.

PROJECT TOOLS: Photoshop Elements ● Digital photos
SEE ALSO: Children's storybook, page 108

Create a template

1 Run Photoshop Elements and click **Edit** from the **Welcome** screen. Click on **File** then **New, Blank File**. In the **New** dialogue box, select **International Paper** from the **Preset** menu, then **A4** from **Size**. Change **Width** to the distance between the mask's eye holes – **5cm (2in)** for children or **6.4cm (2.5in)** for adults. Set **Background Contents** to **Transparent**. Click **OK**. Press **Ctrl+0** to see the whole of your canvas. Click the **Marquee Tool** icon in the toolbox.

Draw an eye hole

2 Select **Elliptical Marquee Tool** from the fly-out options that appear. In the **Options** bar, set **Feather** to **0** and untick **Anti-alias**. Set **Mode** to **Fixed Size**, and both **Width** and **Height** to **1cm (0.4in)**. Click anywhere on the canvas to select a circular area. Choose **Fill Selection** from the **Edit** menu. Set **Contents** to **White, Mode Normal, Opacity 100%**, and untick **Preserve Transparency**. Click **OK**. Press **Ctrl+C** to cut the circle, then **Ctrl+V** to paste it.

Add a picture

3 The white circle is now centred within the canvas. From the **Image** menu, choose **Resize**, then **Canvas Size**. Change **Width** to half the width of the paper that you are using – **10.5cm** for A4. Click the right **Anchor** position. Click **OK**. Now go to **Open** on the **File** menu and open the photo you want to use. Press **V** for the **Move Tool**, then drag the photo onto your blank template.

○ Mirror, mirror...

Mirroring is a good way to create a symmetrical mask. But the results may be very different depending on which half of a particular face you choose to mirror. Before dragging a photo onto your mask template (see step 3 of this project), look at it and decide which is the better side of the face. If it isn't on the left of the photo, flip the face over – go to the **Image** menu and choose **Rotate, Flip Horizontal**. Mirroring different sides of the same face can produce unexpected and humorous results (see right), so experiment.

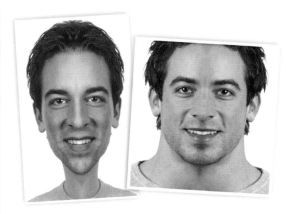

● Masks without mirrors

Some faces don't mirror well, especially if they're very asymmetrical to start with. Rotating slightly (as in step 4, below) often helps. Alternatively, use a photo without mirroring it. After resizing the canvas in step 3 of this workshop, skip to **Select All** in step 6. Click **OK** to resize the canvas again, add your photo and adjust its size and position (as in step 4) to fit the two eye holes. Draw around the whole outline and delete the background (steps 5 to 6).

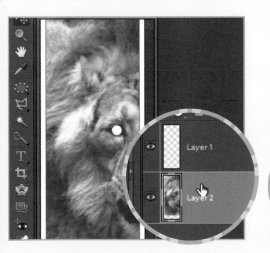

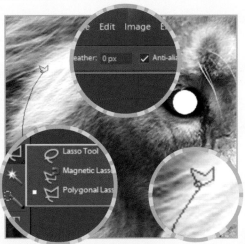

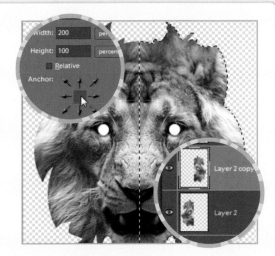

Size the picture to fit

4 In the **Layers** palette (choose **Layers** from the **Window** menu if you can't see it), drag your picture, **Layer 2**, to below **Layer 1**. The white circle appears over the photo. Resize, rotate and position the photo (see 'Moving objects around' box, page 110) so the eye coincides with the eye hole, the centre of the face is aligned with the right edge of the canvas, and the face fills the canvas as well as possible. Press **Return**.

Cut around the edges

5 Click on the **Lasso Tool** icon in the toolbox on the left, and select **Polygonal Lasso Tool** from the fly-out options. In the **Options** bar at the top, set **Feather** to 0 and tick **Anti-alias**. Click on the canvas at any point along the proposed edge of the mask, then at short intervals right around your planned cutout line, back to the position you started at. Press **Shift+Ctrl+I** to invert your selection, then **Delete** to erase the background.

Mirror your mask

6 Press **Ctrl+A** (Select All) and choose **Crop** from the **Image** menu, then press **Shift+Ctrl+E** to merge the layers. Go to **Canvas Size** as in step 3; set **Width** to **200 percent** and **Anchor** to the left. Click **OK**. In the **Layer** menu, choose **Duplicate Layer** and click **OK**. Press **Ctrl+A**, and go to **Image, Rotate, Flip Selection Horizontal**. Finally, save your mask as a Photoshop (*.PSD) file.

Once upon a time
Make a children's book starring the people they know

A storybook is a marvellous project to do with children, or to make as a gift for them. Drawing skills are not needed, because you work from photos, and you don't have to write a lot unless you want to – the main aims are to tell a good story and make it look great. If you have photos of the children concerned, they'll love to see themselves in the story.

This project takes you through the process of creating an eight-page storybook. You can adapt the ideas using your own theme and photos. Create as many pages as you wish, so long as it's a multiple of four if you're going to bind your book (see box page 115).

PROJECT TOOLS: Photoshop Elements ● Photos ● Colour printer
SEE ALSO: Draw a comic strip, page 48

○ Design a cover

A storybook cover often features an illustration from inside. Create a blank file and drag in a picture from a page you've made. Choose a picture that can fill the page, then use the **Horizontal Text Tool** from the **Text Tool** fly-out on the toolbox to add your title. For impact, add a warp effect. In the **Layers** palette, select the layer containing the text you want to warp; here it's the middle word of the title, which has been created separately. From the **Layer** menu, choose **Type**, **Warp Text**. Pick a shape from the **Style** menu and adjust the **Bend** slider for an effect you like.

Create your first page

1 Run Photoshop Elements and click **Edit**. From the **File** menu, choose **New**, **Blank File** (or press **Ctrl+N**). In the **New** dialogue box, choose **International Paper** from the **Preset** menu, then select **A4** from the **Size** menu. Set the **Color Mode** to **RGB Color** and **Background Contents** to **White**. You'll create your storybook one page at a time, leaving the cover until last – so page 2 is the first. Type Storybook Page 2 in the **Name** box at the top. Click **OK**.

Open a picture

2 Choose **Open** from the **File** menu (or press **Ctrl+O**). In the **Open** dialogue box, select a photograph that you would like to use for the beginning of your story and click **Open**. One way to think of your story is as if it were a movie. In films an 'establishing shot', usually a long shot, is used to set the scene for the viewer. Here we are using a long shot of the zoo, which is where this story is set.

Fit the picture to your page

3 Press **V** for the **Move Tool**. Click on the photo and drag it over onto the blank page. Release the mouse button, then drag the photo to the top left corner of the page. Resize it by dragging the bottom right corner handle, making it cover the whole page. Hold down the **Shift** key to prevent the photo from changing shape. Press **Return** to finish, then drag the photo to adjust its position if necessary.

Moving objects around

The **Move Tool** works on the layer that's highlighted in the **Layers** palette, or the part of it within a selection you've made (shown by a flashing dotted outline). When you activate the **Move Tool** (press **V**), a 'bounding box' surrounds the affected area. If you don't see this, tick **Show Bounding Box** in the **Options** bar. Drag within the box to move it, drag a corner to resize, or place the mouse pointer just off a corner and drag to rotate it.

Preparing to lasso

Before starting a **Lasso** selection (see box, page 111), press **Z** for the **Zoom Tool**, and drag a rectangle around the objects you want, so they're visible at a good size. Start lassoing, and once you're nearly all the way around, double-click to finish. If you double-click too soon by accident, deselect (**Ctrl+D**) and start again. Alternatively, finish by returning to your start point – the mouse pointer shows a tiny circle – then click once.

Add some text

4 Book text is usually black – but you can use any colour you like. Use white text on a dark background. Click and hold the **Type Tool** icon in the toolbox and select **Horizontal Type Tool**. In the **Options** bar at the top, choose a clear sans serif font, such as Arial or Verdana, and a large size, 24pt say. Then click the triangle next to **Color**, at the right, and choose **White** from the drop-down menu.

Use a shadow to emphasise the text

5 Click near the top of the page and type some text. To finish, click the **Move Tool** icon twice at the top of the toolbox. Position your text well away from the edges of the page. In the **Effects** palette (choose its name in the **Window** menu if you don't see it), click the second icon, **Layer Styles**, then select **Drop Shadows** from the menu. From the options below choose **Soft Edge**, and click **Apply**.

Make another page

6 Choose **Save** from the **File** menu, (or press **Ctrl+S**). In the **Save As** box, choose where to save your storybook, then click the **Create New Folder** icon at the top. Type Storybook as the name of the new folder, then click **Open**. Click **Save** to store the page you've made. Now press **Ctrl+N** to make a new blank page. Set it up the same as before (step 1), naming it Storybook Page 3. Click **OK**.

How to lasso

You can use the standard **Lasso Tool** to draw around an object freehand – hold down the mouse button and keep dragging. But you'll need a steady hand. It's easier to use the **Polygonal Lasso Tool** (see step 7) to draw a series of straight lines; for more precision, draw short lines. For a storybook, draw roughly with longer lines, leaving a gap around the objects you're selecting so it will look as if you cut them out with scissors.

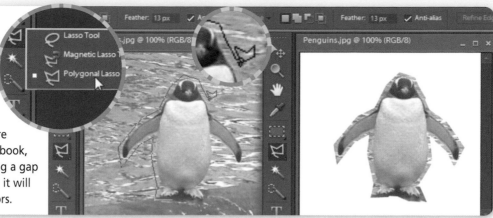

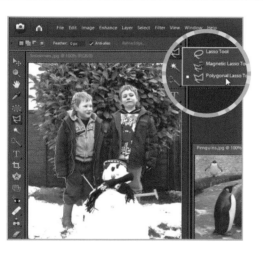

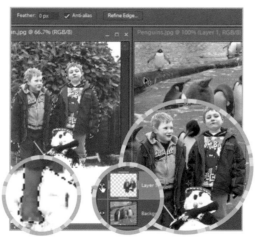

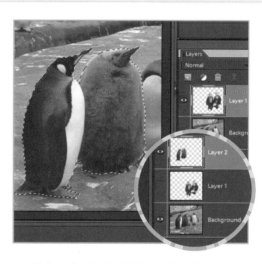

Create a photo collage

7 Open two photos that can be put together to make a scene. Here, the boys will make perfect penguins. To cut them out, click and hold the **Lasso** icon in the toolbar on the left of the screen and select **Polygonal Lasso Tool** from the fly-out menu. In the **Options** bar, set **Feather** to **0**. Click on the edge of the area you want, release the mouse button, move to draw a straight line, then click again to position it.

Move the cutout

8 Continue all around the outline, and join your line back to the beginning or double-click to finish. Press **V** for the **Move Tool**, and drag your cutout onto the penguin photo. Position the boys to fit in with the group and press **Return** to confirm. In the **Layers** palette on the right (choose **Layers** in the **Window** menu if you can't see it), click the eye next to the top layer to hide the cutout.

Duplicate some picture elements

9 Click **Background** to edit the background layer. Press **L** for the **Polygonal Lasso Tool**, and then draw around your chosen elements — here, two penguins. When you've completed your selection, press **Ctrl+J** to copy this area into a new layer, which appears in the **Layers** palette as **Layer 2**. Press **Shift+Ctrl+]** to bring it to the front, or drag it to the top of the list in the **Layers** palette.

● Jazzy effects

A quick way you can spice up a photo to use on a storybook page is to apply a colour effect. There are several under **Adjustments** on the **Filter** menu. Choose **Photo Filter**, then pick from the **Filter** menu and adjust the **Density** to set the strength of the effect. Choose **Posterize** and set a small number of **Levels** for a Pop Art effect. Or for a psychedelic image, choose **Gradient Map** and pick a colourful gradient from the menu.

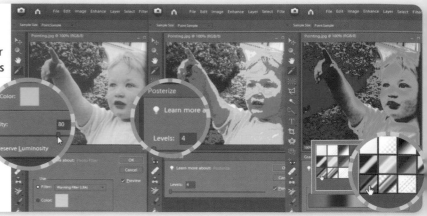

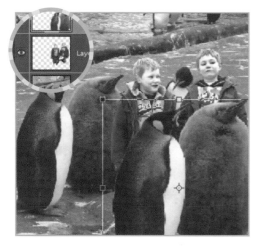

Enlarge the elements

10 Now click the eye to show the boys' layer again. The elements you copied are now in front of them. Press **V** for the **Move Tool** – a dotted box appears around the penguins, since their layer is currently selected in the **Layers** palette. Holding **Shift**, drag a corner of the box to enlarge the penguins, so they look as if they're in the foreground. The box's dotted line becomes a solid line.

Flip the elements

11 Press **Return** to confirm the changes. To make it less obvious that the penguins are repeated, in the **Image** menu choose **Rotate, Flip Layer Horizontal**. In the **Layer** menu choose **Flatten Image**. Everything is merged onto the **Background** layer. With the **Move Tool**, drag the picture onto your blank page 3. Resize it, holding **Shift**. You'll need to adjust the shape to fit on the page.

Complete your page with text

12 Drag the bottom right corner of the window containing page 3 to make it larger than the canvas, revealing the background. Drag a corner of the picture to resize it bigger than the page, cropping off the edges. Leave a space at the bottom to put your text. Press **Return** to finish, then add text as in step 4. This time set **Color** to black. Save your page using **File, Save**.

● Matching colours between photos

To use two photos within a story that are differently exposed, tint one to match the other. On the stronger coloured picture, choose **Blur** from the **Filter** menu, then **Average**. It fills the canvas with a single colour. Press **V** for the **Move Tool** and drag the block of colour onto your other picture. In the **Layers** palette, set blending mode to **Color**, and adjust **Opacity** percentage to get the desired colour match.

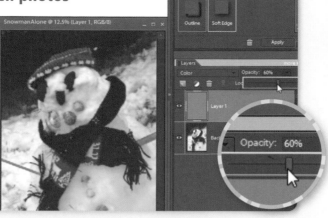

● Large images and memory

An A4 page of images at 300dpi (see 'Size matters', page 23) makes a large file of around 25Mb (megabytes) and it grows if you add layers. If you have a few files of this size open at the same time, as you will when creating the pages of your book, Photoshop Elements may get short of memory (RAM). You'll hear the hard disk whirring and your PC will slow down. To avoid this, close any pages or photos you're not currently working on.

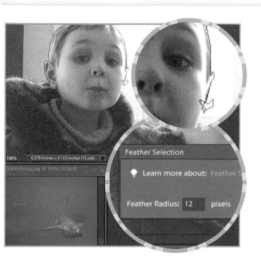

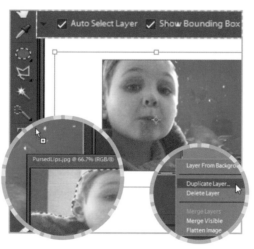

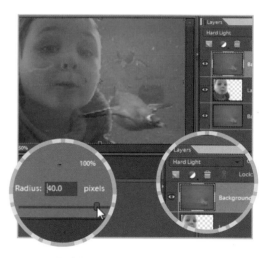

Cut out a face

13 Make another new page (see step 1), and name it Storybook Page 4. Again, open the two photos you want to combine. Here, one of the boys will join the penguins underwater. Draw around the boy's head and shoulders with the **Polygonal Lasso Tool** (press **L**), and join your line back to the beginning. Choose **Feather** from the **Select** menu, enter **12** in **Feather Radius** and click **OK**.

Sizing and positioning the cutout

14 Press **V** for the **Move Tool** and drag the face onto the underwater photo. Feathering (see step 13) gives it a soft edge. Enlarge the window, as in step 12, so you can size and position the face beyond the edges of the canvas. Press **Return** to finish. Now to make the face look as if it's underwater. In the **Layers** palette, right-click on the **Background** layer. Choose **Duplicate Layer**.

Blend to combine layers

15 Click **OK** to make a copy of the underwater scene in a new layer, called **Background copy**. Drag it to the top of the list in the **Layers** palette, bringing it in front of the face. Now click the **Blending Mode** menu at the top left of the **Layers** palette and change it from **Normal** to **Hard Light**. From the **Filter** menu, choose **Blur**, then **Gaussian Blur**. Set **Radius** to 40 and click **OK**.

● Turn a photo into a colouring picture

To convert a photo into a black and white line drawing use filters such as **Photocopy** (see steps 17 to 18, page 54). Children prefer a drawing divided into distinct areas that are easy to colour in. You can create this by tracing over the photo manually, using straight lines. Open a photo and press **Shift+Ctrl+N** to make a new layer. Click the **Shape Selection Tool** icon in the toolbox and select the **Line Tool** from the fly-out menu. In the **Options** bar, set **Weight** to **6px** and **Color** to **Black**. To draw a line, click, drag and release the mouse button. Without moving the mouse, click again to start the next line. Draw the main features. Next, scroll down the **Layers** palette and click **Background**. From the **Edit** menu, select **Fill Layer**. Choose **White**, **Normal**, **100%**, and click **OK**. Choose **Flatten Image** from the **Layer** menu.

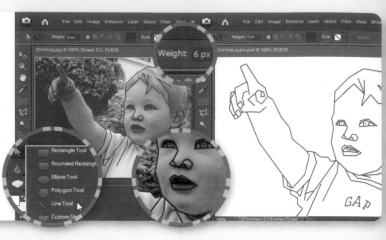

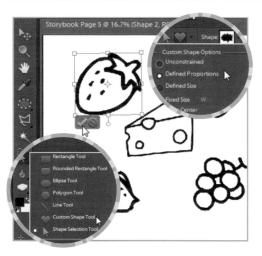

Copy the text

16 The large blur you just created removes details while preserving the water's colour. Choose **Flatten Image** from the **Layer** menu, then use the **Move Tool** (press **V**) to drag the picture onto your blank page 4, positioning it similarly to page 3 – move the windows side by side to compare. Drag the text from page 3 to page 4 to copy it, then use the **Text Tool** to edit it. Save your page.

Build a colouring page

17 Make a new page, Storybook Page 5. To draw objects, click the **Shape Selection Tool** icon in the toolbox on the left and choose **Custom Shape Tool**. In the options bar at the top, click its triangle and, in the pop-up box, click **Defined Proportions**. Click the triangle to the right of the current **Shape**, for a palette of shapes. Click the double triangle, top right of palette, for a menu of shape categories. Use the **Move Tool** to size, position and rotate each shape.

Reuse your page layout

18 Drag text from page 4 onto this page and edit it using the **Text Tool** from the toolbox. Save Storybook Page 5 using **File**, **Save**. This page will also form the basis for a blank drawing page at the back of the book. In the **Layers** palette, **Shift+Click** all the shape layers to select them. Right-click one and choose **Delete Layer**. Click **Yes** in the box to remove all the shapes.

Printing your storybook

Start by opening all your finished pages, and choose **Print** from the **File** menu. Click **Page Setup** and choose your paper size, then click **Printer**. Select your printer and click **Printer Preferences** to adjust its settings, including the paper type you're using – a good-quality glossy photo paper gives best results. Click **OK** to return to **Print Preview**. Click **Print** to print the current page. Close it and repeat for the next. Alternatively, click **Print Multiple Photos**. The **Organizer Workspace** opens and shows the **Print Photos** dialogue box. Under **Select Type of Print**, choose **Individual Prints**. Click **Print** to print all your photos.

Bind your book

For a professional look, buy sheets of heavy art paper and stick your printed pages to them, one page to each side. Leave a wide margin at the front left and back right of each sheet, lie the sheets flat in the right order and staple through the margin. Cut a strip of paper and glue it over the staples.

Or, use sheets double your page size. Take a quarter as many sheets as you have pages, fold each in half and crease. Unfold the sheets and lay them on top of each other. With a needle and thread, stitch along the fold. Stick your pages onto the sheets.

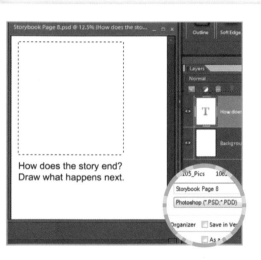

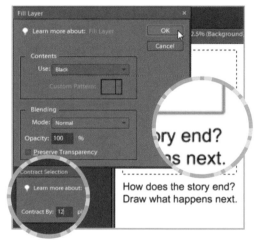

Construct a drawing page

19 Edit the text to invite readers to draw their own picture. Choose **Save As** from the **File** menu. Change the file name to Storybook Page 8 and click **Save**. Click the **Marquee Tool** icon in the toolbox, and select **Rectangular Marquee Tool** from the fly-out options. Click a little way in from the top left corner of the canvas and drag to draw a box to frame the reader's art. In the **Layers** palette, click the **Background** layer.

Add a border

20 From the **Edit** menu, choose **Fill Selection** (the **Fill Layer** dialogue box appears). Under **Contents**, **Use** choose **Black**. Set **Blending**, **Mode** to **Normal**, **Opacity** to **100%**. Click **OK**. Go to the **Select** menu and choose **Modify**, then **Contract**. Type 12 and click **OK**. Go back to **Fill Selection** and, in the **Use** box, change **Black** to **White**. Click **OK** to leave a black border. Save your page.

Design the remaining pages

21 Add pages 6 and 7, using **Ctrl+N** (see step 1), or reuse an existing page – save with a different name, as in step 19, then edit the text and drag in a new picture. Here, a photo taken inside a tent will represent the Snow King's palace. To turn the warm red scene to icy blue, press **Ctrl+I** to make a negative. Add a cover (see box, page 109) and print your book as explained in the box above.

Useful terms and technologies
A quick reference guide to help you cut through the jargon

While all attempts are made to avoid jargon, there are times when only the technical term will do. This glossary explains common terms that you will come across while working through the projects on this book. To help you get more from the definitions, some technical words are highlighted, in blue, to indicate that the term is defined more fully elsewhere in the glossary. Web addresses are in red.

A

ADSL Asymmetric Digital Subscriber Line. Type of broadband internet supplied through your existing phone line. A plug-in splitter box allows you to use your phone for voice calls while your PC is connected to the internet.

analogue A device or a signal that moves or varies continuously rather than in the discrete steps of a digital equivalent. An old-fashioned thermometer, for example, using an expanding and contracting column of mercury is analogue, while a thermometer with an LED display is digital. Two other familiar analogue devices with digital equivalents are clocks and radio tuners. Computers work digitally, by converting words and pictures into numbers, so that they are infinitely reproducible with no loss of quality.

animated GIF A single graphics file containing a sequence of images that play as a simple animation. GIF animations are easy to make and are often small in size, making them ideal for use on web pages and emails.

anti-aliasing A technique that reduces the jagged or 'stepped' appearance of objects on screen, which is particularly noticeable when graphics or text are magnified.

anti-virus software Software designed to detect and remove malicious programs from your PC and incoming emails. The anti-virus software on a PC regularly updates itself to combat new threats as they appear.

AutoShapes Ready-made graphic elements such as rectangles, circles, stars and speech bubbles that you can add instantly to a word-processing, design or page-layout document.

B

banding A printer malfunction that produces visible horizontal bands across a page instead of a smooth gradation between different colours.

bandwidth The amount of data that you can send or receive over a network, usually your internet connection, in a fixed period of time. Expressed as bits per second (bps). The higher the bandwidth, the faster the connection.

bit The smallest unit of computer memory. Eight bits make one byte; 1024 bytes make one kilobyte (Kb); 1024 kilobytes make one megabyte (Mb); and 1024 megabytes make one gigabyte (Gb).

bitmap An image made up of tiny dots or pixels. If you zoom in close, you'll see the dots grow in size, and if you continue to enlarge a bitmap it leads to a blocky appearance. (See dots per inch.) To produce large bitmaps without loss of quality you must use as many dots as possible to create the image, which is why most good-quality digital cameras offer resolutions in excess of five million pixels, or five megapixels. There are many types of bitmap files, but the most common are identified by the file extensions .TIF, .JPG, .BMP and .GIF.

blending A technique used by image-editing programs to combine or 'blend' two images together. This is done by placing one image on top of the other and then controlling the relative transparency and other settings of each to produce a new image.

blog A diary or log that you store on a website and update regularly. Blogs can include photos as well as links to other blogs and websites, and are usually free to set up.

BMP Type of bitmap picture file that can be used by most Windows programs. For example, desktop wallpaper on a PC is a BMP image.

browser A program such as Internet Explorer used to view web pages and surf the internet. Also sometimes applied to programs such as Picasa that enable you to browse the pictures stored on your PC.

brush An image-editing tool that lets you draw freehand within an image on screen in chosen colours or textures. Most image editors let you choose from a vast

range of brush shapes, sizes, styles and settings.

burn The process of writing photos onto a blank CD or DVD using a CD writer.

C

CD-ROM Compact Disc Read Only Memory. The data equivalent of the audio CD, using an identical disc but recorded in a different way. Data on a CD-ROM cannot be changed, added to or erased, unlike blank CD-R discs, which you can add your own data to, and CD-RW (rewritable) discs, which can be recorded over.

CD writer A CD drive included with most home PCs that's able to burn data and pictures onto recordable CD discs.

clip art Ready-made pictures and photos that you can use in your documents and web pages. Sold in collections on CD-ROMs and downloadable from the internet.

cloning A method of painting freehand with colours and texture copied from one part of an image onto a different part of the image. Cloning is used to tidy up blemishes, remove unwanted objects from photos or create special effects.

CMYK Cyan, Magenta, Yellow and Black (K is used for black, rather than B to avoid confusion with the colour blue). These

are the primary colours used in commercial printing processes to print magazines, packaging and posters. Combining them in different percentages produces a wide range of colours and tones.

c:100%	c:100% m:100%	c:50% m:100%
m:100%	m:100% y:100%	m:50% y:100%
y:100%	c:100% y:100%	c:100% y:50%
k:100%	k:50%	k:25%

colour depth Relates to the number of colours that can be displayed in an image, and is expressed as a binary number. An 8-bit image can have a maximum of 256 different colours, whereas a 24-bit image can include up to 16 million colours. A 1-bit image uses only black or white.

colour palette Although your PC may be able to display millions of colours, not every picture needs or uses that many. The actual colours used in any individual image make up its colour palette.

compression A way of making a file smaller by rearranging or removing non-critical information. Compressed files are quicker to download or send as attachments.

crop To select just the part of an image that interests you and trim

off the rest. In an image editor such as Photoshop Elements, this is done using the **Crop** tool.

cutout Part of a picture that's been selected or highlighted then cut out for use elsewhere in the same image or in a different image. Image editors such as Photoshop Elements can keep cutouts on separate transparent layers so they can be repositioned or re-sized at any time.

D

depth of field The range between objects in a photo that are at different distances from the camera, but remain in focus. The lens aperture governs the depth of field. A small aperture increases depth of field. This is why daylight shots (where there is plenty of light, and the aperture contracts to compensate) tend to be sharper overall than poorly lit interiors (where the aperture dilates to let as much light as possible into the camera).

dialogue box A small window that appears in connection with a program running in Windows to display messages and information, and to show configuring options and settings. When a dialogue box contains a large number of options it may be separated into sections using tabbed dividers, like an old-fashioned card index.

digital Refers to data — for example, images — stored as a series of distinct numbers rather than as a continuously variable (analogue) signal. Sound is converted from analogue waves into digital data simply by measuring its amplitude at extremely tiny intervals. Graphical information is stored digitally by dividing a picture into a grid of tiny points and then storing the colour of each point as a set of three numbers representing the amount of red, green and blue at that location. Once data has been converted into its digital format (digitised) it's easy for the computer to handle because the digital information can be translated into the zeroes and ones of the binary system in which computers do their processing.

digital camera A still camera that captures images when light is focused through the lens onto

an electronic sensor. The camera records the colour of each of the millions of pixels that make up a digital picture. Images are stored digitally on small memory cards, rather than on film. You can transfer images to a PC for editing, then erase them from the camera to make space for new pictures.

digital zoom A feature found on cheaper cameras and camera phones that simulates the effect of a real (optical) zoom lens by digitally enlarging the centre of an image. The effect is the same as resizing part of a photo using image-editing software.

digitise To convert analogue images, transfer them to a PC and store them in digital form.

domain name A unique text name used to distinguish one website from another. For example, bbc.co.uk and radiotimes.com are domain names.

dots per inch (dpi) The number of dots that a printer can print on each linear inch of paper. Also the number of dots used to make up a linear inch of a digital image. The greater the number of dots per inch, the smaller each dot and the clearer the picture. Many inkjet printers can print at more than 1440dpi, but most computer monitors will only display at around 92dpi.

drag and drop Clicking and holding the left mouse button on an object, then moving the mouse to drag it elsewhere on screen, and releasing the button to drop the object.

driver Software that translates instructions from Windows into a form that can be understood by a hardware device such as a printer or a graphics card.

drop cap Large, decorative upper-case letter at the start of a paragraph that drops into the lines below it.

DVD Digital Versatile Disc. A CD-like disc that can store roughly six times as much data as a CD-ROM.

DVD writer Device included with many home PCs for burning data, music or movies onto a blank recordable DVD disc.

E

encode To convert a file from one digital format into another, often to compress it or make it smaller.

export To save a document or file created in one program in a format that can be opened in

another. For example, if you've saved a photo in Photoshop Elements but want to send it to someone who doesn't use Elements, you could export the file in JPEG format, which can be opened in any web browser or graphics program.

exposure The amount of light that falls on the electronic image sensor in a digital camera while you're taking a photograph.

F

fill Tool used by graphics programs to paint an enclosed area on an image by filling it with a colour or pattern. Also called **Paint Bucket**.

filter A visual effect, such as mosaic, watercolour or impressionist, applied to an image to enhance or transform it. Photoshop Elements includes dozens of filters, each with its own settings to customise the

way the effect will be applied.

firewall Software or hardware that protects a computer or network from attack or hijack by an

unauthorised third party over the internet.

FireWire A fast data connector found on many modern PCs. Also referred to as an IEEE 1394 connector.

focal length An indication of the angle of view, or zoom factor, of a camera lens. The shorter the focal length, the wider the angle of view. In digital photography the focal length of a lens is measured as the distance from its optical mid-point to the surface of the image sensor. Because there is a wide variance in sensor shapes and sizes, the focal length of digital camera lenses is often expressed by its 35mm (film camera) equivalence. A 24mm lens is considered wide angle, 50mm roughly equivalent to the human eye, and greater than 135mm is classed as a close-up or telephoto lens.

font A particular style of type, such as Helvetica, Arial or Times New Roman. Most fonts can be displayed and printed in different sizes. They can also be styled in bold or italic, or with other effects.

FTP File-transfer protocol. A popular way to upload and download files to and from a website. Some FTP programs are free for personal use, such as SmartFTP, www.smartftp.com.

G

Gb Abbreviation for gigabyte. A measure of storage equivalent to 1024 megabytes (Mb), though it is convenient to regard a gigabyte as 1000 megabytes.

GIF file Graphics Interchange Format. Image format particularly useful for web graphics thanks to its small file sizes and features such as animation (see also animated GIF).

graphics card A circuit board in your PC that contains the electronics and connections required to display images on your computer's screen.

graphics program Software that can display, edit and manipulate images, whether they're photos, paintings or line drawings. Photoshop Elements and Microsoft Paint are examples of graphics programs.

graphics tablet An electronic pen and pad connected to a PC. Used by designers and artists, who find it a more natural and precise way of drawing than using a mouse. Also called a drawing tablet.

greyscale An image made up of a range of tones between black and white. The quality of a greyscale image depends on the number of different shades of grey that are used (just as a colour image's quality depends on the number of shades of red, green and blue).

grid Most design programs allow you to display a grid as a background to drawings and page layouts, making it easier to line up different elements. If you switch on the **Snap-to-grid** feature, objects you position with the mouse will snap into place to the nearest grid line.

H

halftone Method used to represent an image using only black dots, where darker areas are made up of larger dots and lighter ones made up of smaller dots, similar to the process used to print black and white photographs in newspapers.

handle The 'grab handles' at the corners of a picture or graphical object that's being re-sized or re-positioned in an image editor. Click the left mouse button and drag a handle to change the size or proportions of the object.

home page Refers either to a personal web page you create yourself, or to the website you always visit first when you connect to the internet. The latter is also often known as your start page.

hotspot A public place where you can connect to the internet wirelessly using a portable PC or pocket computer. Some hotspots are free, others charge a small fee.

HTML Hypertext Markup Language. A set of layout commands and tags designed for electronic publishing. All web pages are built using HTML. Web-page design programs, such as Microsoft FrontPage, allow you to position items on the screen and format them visually, but when you save the page it's stored as a text file containing HTML commands.

hue The main characteristic of a colour that distinguishes it from other colours in the spectrum. In image editing it's represented by a number between 0 and 359 and usually picked off a colour wheel displayed on the screen.

hyperlink Text or graphic on a web page that you can click with the mouse to jump to another part of the page, a different page on the same site or a different site. Text hyperlinks are typically underlined in blue.

I

image editing Using a graphics program such as Adobe Photoshop Elements to alter the composition, colours and other characteristics of an electronic painting, drawing or photo.

import Method used by one Windows program to open a file created by a different Windows program. Importing a file in this way may not preserve all of the original formatting that was in the file but usually keeps the data intact.

internet service provider Usually abbreviated to ISP. A company that offers access to the internet so you can browse the web and send emails. There's usually a sign-up fee, followed by a monthly charge.

IP address Every computer, while connected to the Internet, has a unique address that is expressed as four numbers, each of which is separated by a dot. For example, Google's IP address is 216.239.39.99. IP stands for Internet Protocol.

J

jaggies Ugly, stair-like steps that appear at the edges of shapes where there should be a smooth, straight line or graceful curve. This is caused when an image is displayed at too low a resolution.

JPEG file Also known as JPG, and pronounced 'jaypeg'. Compressed graphics file format widely used on the internet for storing and

displaying photographs. JPEG photos take up little space and download fast. The compression quality can be specified (in the **JPEG Options** dialogue box) when saving an image as a JPEG file. The more compressed the file, the smaller the file size, although compressing an image can affect the quality.

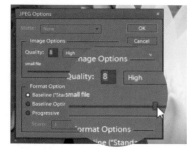

K

kern When you type text onto your PC, the individual characters that make up the words are evenly spaced. Sometimes, it's necessary to adjust, or kern, the space between one or more of the letters – an excessively wide gap between certain letters, for example, or where the edges of two letters touch. Problems that need kerning adjustment are most often visible in headings that use large characters.

L

landscape Turn an ordinary A4 page on its side, so the longer edge runs horizontally, and you're looking at a landscape page. See also portrait.

layers Graphics programs such as Photoshop Elements use layers to help organise complex images. For example, you could use one layer for the main image, a second layer for text and a third for a frame or effect. Think of layers as drawings on transparent sheets. Each can be edited independently, making it possible to alter one part of a picture without affecting the others.

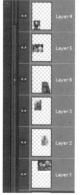

layout The arrangement of text, images and graphical elements on a page when creating documents such as newsletters, posters or web pages.

leading The measurement of the space between lines of text in a document. In a typical paragraph of text, line spacing is constant, but it's possible to alter it on a line by line basis – for example, when adjusting lines of large text to use as headings.

levels The amount of brightness, contrast and colour in the shadows, midtones and highlights of a photo. With Photoshop Elements you can adjust levels manually or optimise them automatically, using **Auto Levels**.

lossy Any compression method that throws away unimportant data to reduce the size of a file, such as JPEG image files or MP3 sound files. The compressed version will contain less detail, but the difference is often not noticeable to the eye or ear.

M

Magic Wand An image-editing tool that selects automatically all pixels within a specified colour range. Useful for making quick cutouts.

marquee The dotted line outlining an area of an image that has been selected for editing in a graphics program. This might be a neat rectangular area or an irregular shape created with a freehand tool or Magic Wand.

Mb Abbreviation for megabyte, which is a measure of the data capacity of a storage device. One megabyte is 1,048,576 bytes but it's easier to think of a megabyte as a million bytes. Main memory (RAM) is measured in megabytes.

megapixel One million pixels. Used by digital camera makers

to describe the resolution of their products. The more megapixels, the better-quality image you should get.

O

OpenType A type of scalable font – called scalable because it can be displayed and printed at any size without losing clarity – that works on both Windows PCs and Apple Macintosh computers. OpenType is an extension of the Windows TrueType font standard.

optical zoom Camera feature that enlarges the image to be captured by changing the focal length of the camera lens. Unlike a digital zoom, the subject is magnified without losing any resolution.

P

page break The point at which one page ends and the other begins. In Microsoft Word, you can manually insert a page break in your document by holding down the **Ctrl** key on your keyboard and pressing **Enter**.

Page Setup In any program that produces printed output, including Word, this command – under the **File** menu – lets you establish options and settings for page elements such as margins, headers and footers, gutter position and page orientation.

pixel An individual dot on a computer screen or on a printed image. The number of pixels horizontally and vertically determines the detail and quality of image that can be displayed. See also resolution.

plug-in A small software program that works in conjunction with a larger application to add extra features to it. For example, Photoshop Elements includes plug-ins that perform special effects on images. Many are supplied already installed with the program, and you can buy or download extra plug-ins to perform new special effects.

POP3 Post Office Protocol 3. This is a standard for sending and receiving messages over the internet. The use of POP3 is a like an agreement between your PC and the computer that sends your mail on how it should be packaged and delivered. Microsoft Outlook Express is known as a POP3 email client as it conforms to this way of handling email.

portrait Orientation of a document or picture in which the short edges are horizontal and the longer edges vertical (the opposite of landscape).

preview A screen that displays how a document will appear when it's printed. By previewing the finished document on the screen before committing it to paper you can make last-minute corrections to the formatting and save on printer ink.

primitives The basic geometrical shapes included in the toolbox of any graphics program. Rectangles, polygons, ellipses and lines are the 'building blocks' with which more complex images are created.

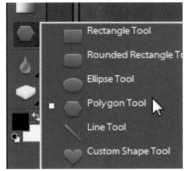

R

RAM Randon Access Memory. Usually refers to the main memory inside your PC, used to store and manipulate data while the computer is switched on. Unlike data on a hard disk, when you switch the PC off, the RAM's contents are lost.

refresh rate The number of times per second that an image on the screen is redrawn. The more often redrawing takes place, the less you will see flickering in the image.

resolution The number of pixels in a digital image, computer monitor, camera or scanner, expressed as either separate horizontal and vertical resolution (for example 1280 x 1024) or multiplied together as a single figure. The higher the resolution, the finer the detail that can be reproduced.

RGB Abbreviation for red, green and blue, the colours used on a PC monitor. By combining these colours in various strengths (expressed either as a percentage or in numbers from 0 to 255) it's possible to create all the colours of the spectrum.

ROM Read Only Memory. Any data storage device that can be read but not written over or re-used – such as CD-ROM and DVD-ROM discs.

runaround Feature that allows text to wrap round pictures automatically without you having to alter each line individually. Programs such as Microsoft Word include several types of automatic runaround.

S

saturation The percentage concentration of a specific colour. The more saturated a colour, the more vivid it appears. Turn down the saturation in an image and it becomes more pastel or muted.

scanner Device that converts drawings, photos, documents, slides or films into data that can be used and manipulated on PCs. The most common type of scanner is a flatbed scanner – a

device with a glass top covered by a lid (similar to the top part of a photocopier). The original printed document, typically of up to A4 size, is placed face down on the glass plate. A photo-electric sensor measures the light reflected from it and records it as a digital image.

screensaver A picture or animation displayed on your screen when the PC has been idle for a set period of time. Some screensavers require you to enter a password before you can start using the PC again.

selection Anything highlighted with the mouse, whether it's an item on a menu, part of an image selected with a marquee, or an entire picture.

SMTP Simple Mail Transfer Protocol. One of the methods by which email is sent on the internet. In a mail program such as Outlook

Express, SMTP handles outgoing messages and POP3 delivers incoming mail.

stitch A feature in photo-editing programs that joins together a series of separate photographs to create a panorama. Many digital cameras include a stitch mode, allowing you to take a sequence of photos, aligned, for subsequent stitching.

T

template In desktop publishing, a template is a predesigned file containing formatting, graphics, text and place holders (dummy text) to help create standard document types such as newsletters and calendars. You type over the place-holding text to replace it with your own.

thumbnail A miniature representation of a picture within a graphics program, on a website or in Windows Explorer. Thumbnails load quickly and enable you to decide whether you want to open the full-size versions.

TIF file Also expressed as TIFF. Graphics file type used by many programs on Windows PCs and Apple Macintoshes and the preferred choice of professional graphic artists and designers. TIFs are large but they can be compressed to reduce file size. Unlike JPEG files, there's no loss of quality on compression.

toolbox In a graphics program, a box holding a collection of tools that are used to apply editing techniques or add items to an image. Some tools have more than one option – these are identified by a black triangle at the bottom right of the tool icon.

transparency Also called opacity. A quality assigned to layers in an image-editing program that allows shapes and colours on background layers to show through.

TrueType A font standard invented by Microsoft and Apple that allows you to display and print text to large sizes without losing quality.
See also OpenType.

TWAIN Means by which scanners and certain other hardware devices, mainly cameras, communicate with graphics programs. The TWAIN driver is installed on the PC and handles the transfer of data from the device to the graphics program. One popular belief is that TWAIN stands for 'Technology Without and Interesting Name'.

U

updates Most software is never finished, so occasionally you need to download updates from the internet that improve reliability, add new features or fix security problems. You can set up Windows XP to update automatically.

USB Universal Serial Bus. USB connectors are included on every home PC and allow you to connect peripherals such as printers, scanners and digital cameras.

V

vector graphics A system of drawing objects using curves and lines, as opposed to pixel by pixel as in bitmap images. Vector images can be resized with no loss of detail.

virus A malicious code designed to replicate itself, often by secretly infecting your emails. There are many kinds of virus, from those that steal sensitive information or erase files to others that display just mischievous messages. Some, called Trojans, lay dormant for months waiting to be triggered on a specific date.

W

webcam A small, inexpensive video camera whose output is viewable on a web page. Some digital snapshot cameras can also be used as webcams. The images from the camera are periodically updated on the web page. A webcam may also be used for video chat but only on a broadband connection.

Wi-Fi Wireless Fidelity. A way to connect PCs wirelessly to the internet (through a wireless modem or Wi-Fi hotspot) or to a home network. Wi-Fi capabilities are built into many handheld and portable computers, and can be easily added to a desktop PC by plugging a Wi-Fi network card into a USB port.

wireless network A way to connect computers and computing devices without the need for wires. For example, two PCs can share a wireless internet connection, a printer, or the same music collection. If you're out and about, you can also connect to the internet using a wireless hotspot. See Wi-Fi.

Index

How to Do Just About Anything with Your Digital Photos

is based on material in **Practical Projects for Your PC**, published by The Reader's Digest Association Limited, London

First edition copyright © 2006
The Reader's Digest Association Limited,
11 Westferry Circus, Canary Wharf, London E14 4HE
www.readersdigest.co.uk

Updated reprint 2008

We are committed both to the quality of our products and the service we provide to our customers. We value your comments, so please do contact us on **08705 113366**, or via our website at: **www.readersdigest.co.uk**

If you have any comments or suggestions about this book, email us at:
gbeditorial@readersdigest.co.uk

Practical Projects for Your PC was created and produced for Reader's Digest by Slowcat Ltd on behalf of Computeractive.

Editor
John Andrews

Art Editor
Conorde Clarke

Technical Consultant
Tony Rilett

Indexer
Marie Lorimer

Reader's Digest General Books

Editorial Director
Julian Browne

Art Director
Anne-Marie Bulat

Managing Editor
Nina Hathway

Head of Book Development
Sarah Bloxham

Picture Resource Manager
Sarah Stewart-Richardson

Pre-press Account Manager
Penny Grose

Production Editor
Rachel Weaver

Product Production Manager
Claudette Bramble

Production Controller
Katherine Bunn

Origination
Colour Systems Ltd

Printed in China

Acknowledgments

Writers: Adam Banks, Alistair Dabbs, Ken McMahon

The position of photographs and illustrations on each page is indicated by letters after the page number: **T** top; **B** bottom; **L** left; **R** right; **C** centre.

Photography: 6-7 © Slowcat Ltd; **10TL, BR** © Fujifilm UK, **TR, BL** © Canon UK Ltd; **11** © Fujifilm UK; **12** © Alistair Dabbs; **13L** © Slowcat Ltd; **13R** © Fujifilm UK; **14-15** © Tony Rilett; **16-19** © Gordon Laing, Adam Banks, Mick Andon; **20-21** © Tim Course; **36TL, BC, BL** © Tony Rilett; **36TC** © Slowcat Ltd; **36BR** © Tim Course; **37T** © Tim Course; **38-39** © Alistair Dabbs; **42-122** © Slowcat Ltd.